Mixed Emulsions

QUARRY

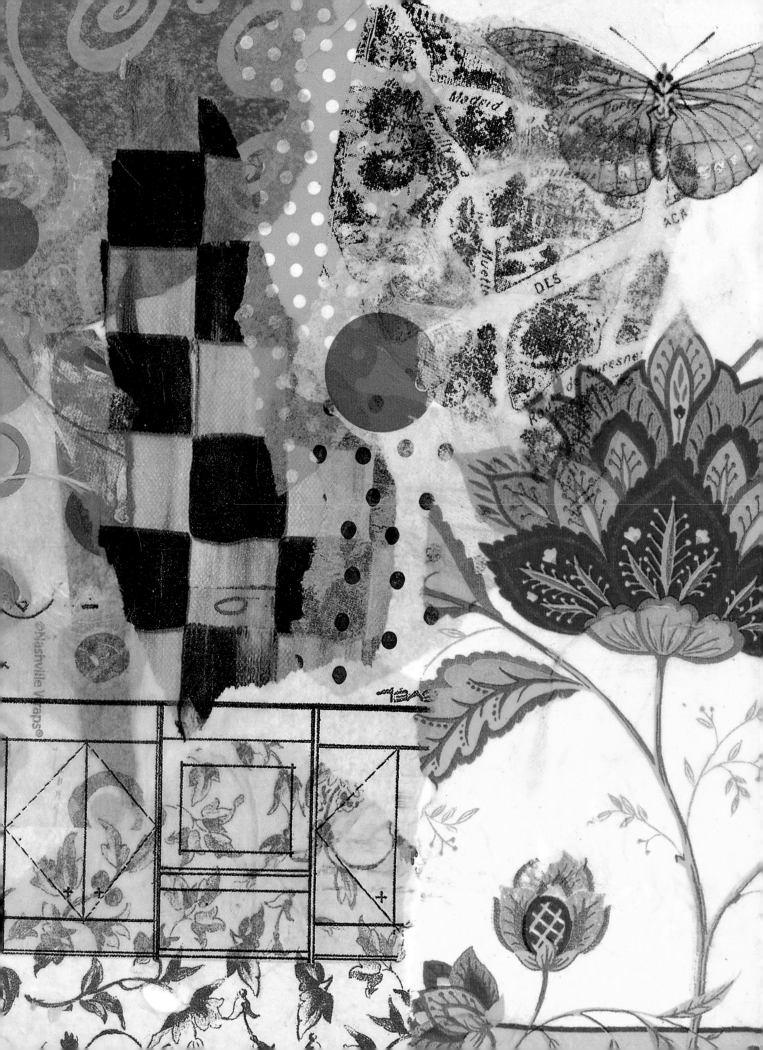

MIXED EMULSIONS

BEVERLY MASSACHUSETTS

QUARRY BOOKS

ALTERED ART
TECHNIQUES for
PHOTOGRAPHIC
IMAGERY

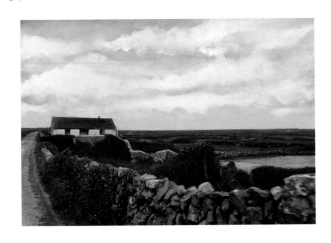

ANGELA

CARTWRIGHT

First published in the United States of America by
Quarry Books, a member of
Quayside Publishing Group
100 Cummings Center
Suite 406-L
Beverly, Massachusetts 01915-6101
Telephone: (978) 282-9590
Fax: (978) 283-2742
www.quarrybooks.com

Library of Congress Cataloging-in-Publication Data
Cartwright, Angela.
 Mixed emulsions : altered art techniques for photographic imagery / Angela Cartwright.
 p. cm.
ISBN 1-59253-369-8
1. Photographic emulsions. I. Title.
 TR395.C335 2007
 772—dc22

 2007016590
 CIP

ISBN-13: 978-1-59253-369-5
ISBN-10: 1-59253-369-8

10 9 8 7 6 5 4

Design: Rachel Fitzgibbon
Cover Art: Angela Cartwright
Photography: Glenn Scott Photography

Printed in Singapore

Life is like photography. You use the negatives to develop.

—*Anonymous*

To my Mum and Dad

who started a lifetime passion when they gave me
the gift of a camera when I was 15.

CONTENTS

INTRODUCTION

If you observe an ordinary object or body very closely, it is transformed into something sacred. The camera can reveal secrets the naked eye or mind cannot capture; everything disappears except for the thing that is the focus of the picture. The photograph is an exercise in observation, and the result is always a stroke of luck.

—ISABEL ALLENDE

THE RAMBLINGS OF AN ARTIST

Photography is the process of making pictures by the action of light. It only takes a thirtieth of a second for photo emulsion exposed to light to form an image. There, in that moment, you have captured time, and to me, that's magic.

Art is about expression. Observing the world and then expressing what you see from your own perspective. Photography can open doors to close observation. A snapshot reveals a moment, but it can also show us so much more — the texture of a wall, the shape of a feather, the complexity of a nest, the expanse of a landscape, the innocence in the face of a child. When you add color or texture, it creates an entirely new work of art, and allows you to explore additional dimensions. A photograph may embrace the depth of the subject within its frame or spill over onto canvas, wood, or paper.

Artists use imagery to create. The imagery itself may arise from your imagination or from a strip of film. Creativity implies following your instincts, and requires no rational explanation. For me, sometimes stories evolve in my head, and other times those stories reveal themselves as the art is created. This mysterious process is what attracts me. We all have stories to tell.

Many years ago my daughter came home from school and said her art teacher had told her she couldn't color the snowman's scarf pink. I saw red. I told her to have the teacher call me if she could not color her drawings whatever color she wanted. Sad to say, my daughter did not get an A in art class that year. The more important lesson was that I let my daughter be who she is, expressing herself her way. Why can't the snowman's scarf be hot pink and lime green? That sort of individuality is what makes an artist an artist.

My father was a technical artist, and I always admired how his drawings looked exactly like the objects they were supposed to portray. It took years to realize that this approach was my downfall. I was stuck in the limbo of not being able to draw or paint like I wanted to: realistically. I thought I wanted my art to be detailed and perfect. I found that photography achieved realism, while painting those images gave me the freedom to express myself. A friend once reminded me that as humans, we are perfectly imperfect. I have used that as a mantra for years now.

There is an Aboriginal idea that everything has to be dreamed to exist at all. I often dream my ideas and have trained myself to wake up just enough to write them down. If I don't, I am haunted by what I can't remember. I recommend that you write all your ideas down. For me, keeping a notebook and pen by my bed has allowed me to clear my mind to make art, art that shows the way I experience my world.

You will never hear me tell you that something should look a certain way. You are you, and what you create will come from deep inside if only you let it. It is my hope that this book opens doors to artistic exploration and compels you to experiment and discover. Take these seeds of inspiration and plant them in your own garden. Be an unruly artist. Create art that shows the way you experience your world.

Enough of my rambling ... let's start at the very beginning.

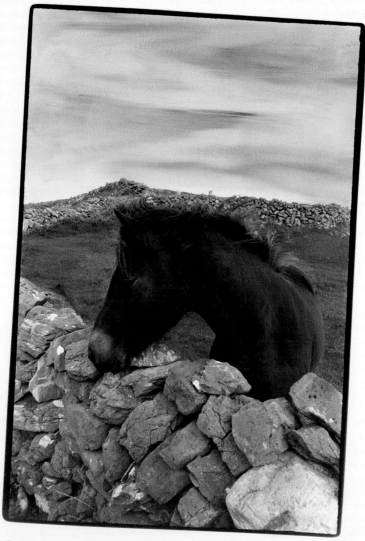

CONNEMARA

ART PARTS

1

You don't take a photograph. You ask, quietly, to borrow it.

—*Anonymous*

IMAGES

When the bug bit me to take my photographic passion to another level of discovery, I knew the journey would be an exciting one. Every year there are new developments in art products and new ways to use them. The art of discovery and the power of learning make me rekindle my childhood spirit.

Throughout this book we'll explore the many ways I have discovered that photographic images can be colored, textured, and altered. The specific products and materials used on each of my sample photographs and mixed-media works are listed in the back of the book. You will also find the companies that produce these products starting on page 141.

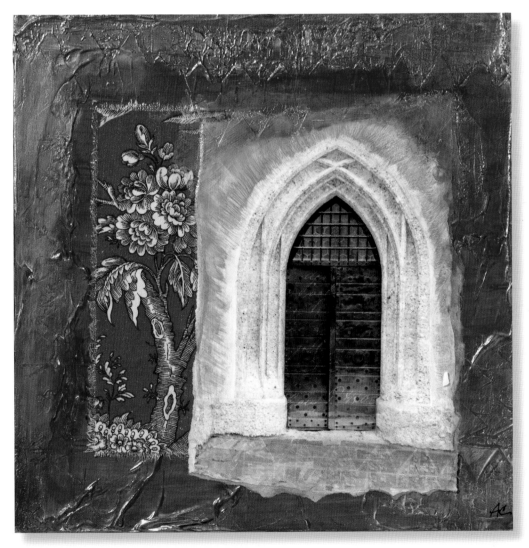

PORTAL — Black-and-white photograph hand-painted with oils and stamped into, acrylic paint, embossing powders stamped into, fabric, inks

BLACK-AND-WHITE PHOTOGRAPHY

I love black-and-white film photography. To me, it's about tonal relationships and contrast. It feels pure and tangible, creating impact with it's graphic quality. Shooting in black and white is an artful and rewarding experience, and the results are comfortably incorporated into altered art. The process of developing the film, printing the image, and holding the captured moment in one's hand is very satisfying.

To the right you will find a short list of photographic terms, which as a photographer you will no doubt encounter.

ALL THAT JAZZ — Black-and-white photograph

Basic Photography Terms

Aperture is the stops on a photographic lens that can be adjusted to control the amount of light reaching the film or image sensor. With a variation of shutter speeds, the aperture size will regulate the degree of light exposure on the film. A faster shutter speed will require a larger aperture to ensure sufficient light exposure, and a slower shutter speed will require a smaller aperture to avoid excessive exposure.

Depth of field in film and photography refers to the distance in front of and beyond the subject that appears to be in focus. There is only one distance at which a subject is precisely in focus, and focus falls off gradually on either side of that distance.

Exposure is the total amount of light allowed to fall on the photographic film or medium during the process of taking a photograph.

Film speeds, or **ASA**, were developed in 1943 as a deviation of modern materials and developers and the BS/DIN/ASA international standards of 1960–62. The film speed cannot be altered in any way. The exposure index (EI) represents the sensitivity of the film to light under particular conditions of development.

Photographic emulsion is the light-sensitive layer of a film of paper. It is made of gelatin, with small crystals of light-sensitive silver halide (silver bromide, silver iodide, or silver chloride) suspended in it.

TIMELINE

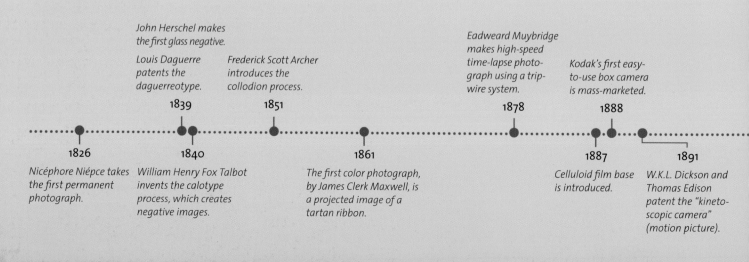

John Herschel makes the first glass negative.

Louis Daguerre patents the daguerreotype.

Frederick Scott Archer introduces the collodion process.

Eadweard Muybridge makes high-speed time-lapse photograph using a trip-wire system.

Kodak's first easy-to-use box camera is mass-marketed.

1839 **1851** **1878** **1888**

1826 **1840** **1861** **1887** **1891**

Nicéphore Niépce takes the first permanent photograph.

William Henry Fox Talbot invents the calotype process, which creates negative images.

The first color photograph, by James Clerk Maxwell, is a projected image of a tartan ribbon.

Celluloid film base is introduced.

W.K.L. Dickson and Thomas Edison patent the "kineto-scopic camera" (motion picture).

COLOR PHOTOGRAPHY

A great color photograph can be narrowed down to three essential elements: composition, lighting, and vivid color. Vibrant color is easier to achieve than ever before with the advances that have been made in color film.

There are two kinds of color film that are used today:

Color negative film forms a negative image when exposed, which is fixed during developing. This is then exposed onto photographic paper to form a positive image.

Color slide film, also known as reversal film, forms a negative image when exposed, which is reversed to a positive image during developing. The film can then be projected onto a screen. Because the process of developing color film is so readily available and inexpensive, it has enabled color photography to make its way into altered art. While a color photograph can stand on its own, artists are experimenting with ways to alter these photographs and incorporate them into their art.

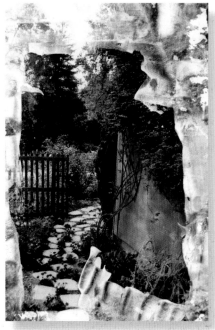

DANCING BY THE GATE — *Color photograph, bleach*

◄ To achieve this manipulated look, dip a lab-processed photograph in water to soften the emulsion, and then color it with markers. Use your fingernail, sandpaper, or a blunt tool to scratch into it. The use of paints, dyes, inks, or markers can create an intense and colorful image.

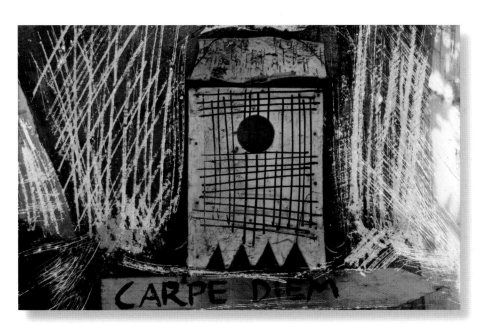

CARPE DIEM — *Color photograph, markers, poster paint pen, walnut ink*

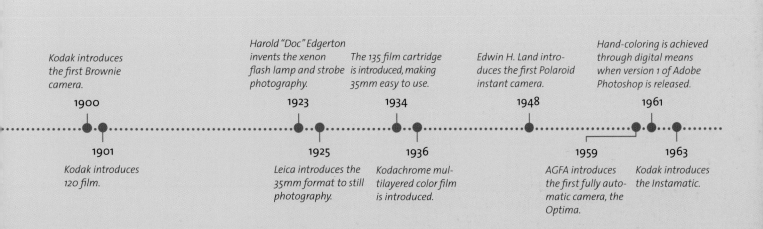

Kodak introduces the first Brownie camera.
1900

Kodak introduces 120 film.
1901

Harold "Doc" Edgerton invents the xenon flash lamp and strobe photography.
1923

Leica introduces the 35mm format to still photography.
1925

The 135 film cartridge is introduced, making 35mm easy to use.
1934

Kodachrome multilayered color film is introduced.
1936

Edwin H. Land introduces the first Polaroid instant camera.
1948

AGFA introduces the first fully automatic camera, the Optima.
1959

Hand-coloring is achieved through digital means when version 1 of Adobe Photoshop is released.
1961

Kodak introduces the Instamatic.
1963

DIGITAL PHOTOGRAPHY

The popularity of digital photography has opened up a new world of experimentation. While I love the purity of film photography, I also love my digital camera. I further enhance and alter these images with a good photography-editing software program. Consider purchasing one for yourself, though heed my fair warning: playing with digital images is very addictive. You can turn a digital image to black and white, to a sepia tone, or wash it out. Play with the hue and saturation buttons and your picture is altered before your eyes. Formal classes or online workshops in Photoshop and other similar programs are certainly a plus, but are not necessary if you like to learn by experimenting.

• Make a copy of your original image before you start altering it. That way you always have the original to alter again and again.

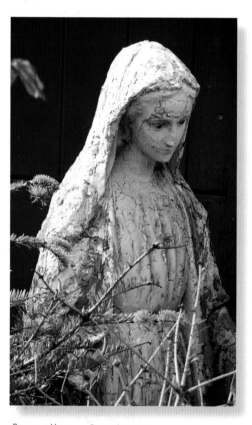

BLESS YOU — Digital image

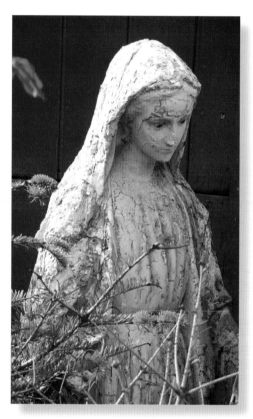

BLESS YOU — Digital image with hue and saturation adjusted

I always carry a small digital camera with me wherever I go. There are plenty of things to photograph in the world around us. When you are out and about, don't forget to look down and see what you're standing on. I have found images of carpets and rugs to contain terrific patterns to use as backgrounds for the photographs I use in my art.

RITZ CARPET — Digital image

MELDING TRADITIONAL WITH DIGITAL

Take a traditional photograph and scan it into your computer. Make a copy of it to alter in your photo program. Go to the filter drop-down button and choose from a large selection of filter choices. If you choose to color a photograph with paints or other materials, scan it and try different filters. You will marvel at the possibilities.

OLIOS — Black-and-white film sepia photograph

Rough pastel

Poster edge

Stamp

Dry brush

Film grain

Craquelure

Palette knife

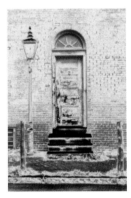

Solarize

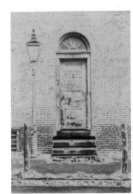

Neon glow

POLAROID MANIPULATION

It is great fun to manipulate a Polaroid photograph. An eerie distortion results when you take a freshly shot Polaroid photograph and wiggle and move the emulsion around. It's a marvel every time, and with a little practice, you will learn to finesse and create a one-of-a-kind and often haunting image. The look may not be for everyone, but I love the surprise of it all!

To experiment, I took five Polaroids of my antique dollhouse and manipulated each one of them differently. A mechanical pencil, an orange stick, a knitting needle, and a stylus all lend themselves to creating an original impressionist display. You can also peel the sides and back of the Polaroid away to achieve a perfect, automatic border.

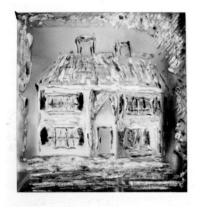

DOLLHOUSE GHOSTS — *Polaroid manipulation*

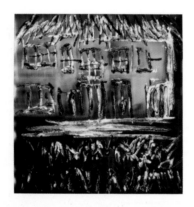

GHOST SHADOWS — *Polaroid manipulation*

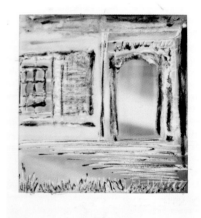

GHOST DOORWAY — *Polaroid manipulation*

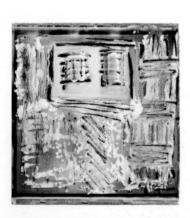

GHOST WINDOWS — *Polaroid manipulation*

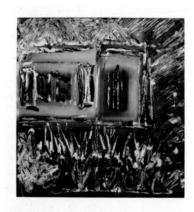

GHOST FLOWERS — *Polaroid manipulation*

LOMOGRAPHY

When I need inspiration, I always grab my Lomographic cameras and shoot. Why? Because you never know exactly what picture you are going to get. The Holga camera is a favorite of mine because it's lightweight and delivers great pictures. This plastic low-tech camera was developed in Hong Kong in 1982. Making its way to the Western world in the late 1990s, it became a favorite at photography colleges and art universities. The Holga is inexpensive and delivers a terrific 6x6 film format (among other size formats) without the weight of a large-format camera. With simplistic settings and a totally uncomplicated format, it encourages you to look before you take photographs, and shoot from the hip. Without having to prepare numerous settings, you can just find inspiration and shoot fast. The camera always offers up innovative, original images and propels me out of any photographic rut I might be in. It's an inspiring gem in the photographic world of film photography.

WINTER WONDERLAND — Black-and-white Holga photograph

Fish-eye Lens

The fish-eye lens and the ability to make multiple and overlapping exposures add to the fun and flexibility of this unique camera. They also make for some outrageous photographs that can fuel artistic expression.

THE BAKERY — Holga fish-eye lens, black-and-white photograph, markers

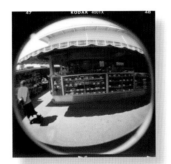

Double Exposure

The Holga was born from a photographer's desire to experiment. Double exposures can make a simple shot twice as interesting. Take a picture and forward your film a couple of frames, then shoot the same subject or something completely different. Faces, clouds, and landscapes can create a fascinating sandwiched image.

NUT HOUSE — Holga fish-eye lens, black-and-white double exposure, markers

Multiple Exposures

For this picture, I shot it vertically, advanced the film a couple of sprockets and shot the car on the street, and then advanced the film again and shot the schoolchildren horizontally. The outcome from my toy camera is an unexpected phenomenon.

DUBLIN ENERGY — Black-and-white triple exposure Lomographic photograph

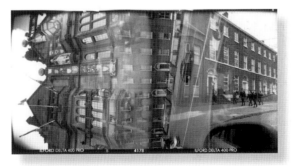

TIMELINE

The first Holga camera is born.

1982

The Lomographic Society International is founded.

1992

1990s

Holga becomes popular in the United States.

2003

Lomographic photography becomes popular worldwide.

> Every other artist begins with a blank canvas, a piece of paper ... the photographer begins with the finished product.
> —EDWARD STEICHEN

SUBSTRATES

Just as the different substrates you use for your art can deliver different results, so can different photo papers achieve different results when you print your photographs. Experiment with some of these yourself, or see whether your professional lab does any of these processes.

PHOTOGRAPHIC SUBSTRATES

Gelatin silver print fiber-based papers are museum-quality and are made of archival natural fiber. Used for high-quality prints and for maximum archival stability of at least seventy years or longer, they consist of a paper base covered with a layer of baryta (barium sulphate), which whitens the paper, holds the photographic emulsion, and prevents the image from sinking down into it. The silver content is in the emulsion. What is exposed on the photograph stays on the paper being developed and what is not exposed falls from the paper into the fixer. It's the combination of chemicals that produces warmer, cooler, or more neutral-toned paper. They are available as both thin single-weight papers and thicker double-weight papers. Many photographers still use fiber-based paper for high-quality exhibition prints despite the greater convenience of RC papers.

Platinum prints are based on the light sensitivity of iron salts. The iron salts react with platinum salts to produce platinum metal. The iron salts are then removed, leaving a stable platinum image. Like other iron processes, platinum printing is slow and requires a UV light source and large negatives, as all exposure is contact printing.

Increases in the price of platinum around 1910 to 1920 led to a rapid reduction in their availability and use. A few photographers continued to print in platinum, making their own papers, but most used other materials.

These photographic prints often sell for many times what a similar silver gelatin print would sell for; the prints include special processes and emulsions that, if processed correctly, are inherently more stable than the paper base they are printed on.

Resin-coated papers (RC) typically have a life span of around thirty to forty years. The paper base of resin-coated photographic paper is sealed against the chemicals used for processing the paper by two polyethylene layers. Because no chemicals and no water soak into the paper base, the time needed for processing (washing and drying) of the paper is significantly shorter than the time needed for fiber-based papers. A traditional black-and-white RC print can be finished and dried in ten to fifteen minutes unlike the washing time of a fiber print, which may take over an hour.

Color papers All color photographic materials available today are coated with either RC (resin coated) paper or a solid polyester. The photographic emulsion used for color photographic materials consists of three-color emulsion with layers of cyan, yellow, and magenta and other supporting layers.

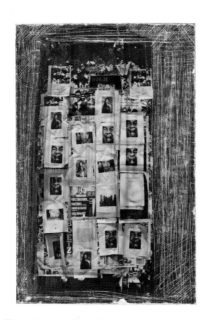

FACE IT — *Color photograph, sanded, markers*

TONING EFFECTS

Selenium toning is used on prints after they have been fixed and washed. Its tone cools the image slightly, removing any olive hint, and the shadows in your image can get a distinct purplish black hue. This toning method intensifies the shadows and brings out shadow detail but does not affect highlights in your photograph.

Sepia toning replaces the silver in the black-and-white photographic print with silver sulphide, which is brown. The print is first bleached, briefly washed, and then treated with the sulphide toning solution. Different tones of browns can be obtained. Often connected to "old-fashioned prints," sepia-toning your prints provides a wonderful base to start with if you plan to hand-color your photographs with oils. Silver sulphide is more stable than silver, so sepia-toning your prints is also a good archival technique that will increase expected print life.

ARTWORK SUBSTRATES

The following list identifies a number of different surfaces that can be combined with photographic art and used for altered art and mixed-media pieces.

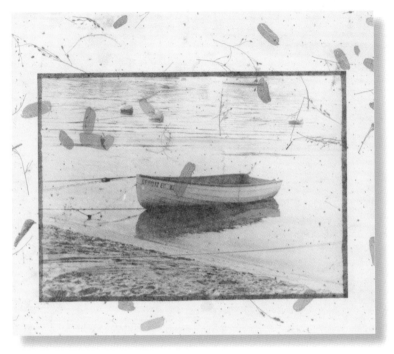

AFLOAT — *Black and white image printed on handmade paper*

Charcoal and pastel papers' finish determines the appearance of the artwork. Both of these finishes can be found in different degrees of texture, from cold press to rough.

Drawing papers resemble bristol paper, but have not been compressed or as heavily sized; the surface is less durable, with a coarse vellum finish and a rougher tooth.

Calligraphy paper is any paper that will not easily bleed, feather, scratch, or wrinkle when used with pen and ink.

Cover papers are of medium weight, 65 to 80 lb (176 to 178 gsm), and are used for covers for booklets and catalogs. They include high-grade construction paper. The better grades are lightfast and quite durable and make good drawing and calligraphy paper. A spray fixative can make this paper more permanent for your artwork.

Other papers can be used for printing photographs since different surface characteristics can produce different textures. Handmade papers, vellum, rag, rice, and silk can all be used if you choose to spend time in the darkroom experimenting.

Alternative substrates, including tin, various fabrics, wood, glass, clay, and tiles, are used by artists searching for unique and unusual surfaces for their photographic images.

Watercolor paper is designed to hold water-based paint and prevent runoff. Painting on smooth paper, such as those used for computer printers, is possible, but the paper will buckle and the paint will remain on the surface, running off in an uncontrolled manner.

The surface of watercolor paper can vary in its smoothness from quite smooth to quite rough. A watercolor painting on rough paper will result in a different effect than a similar painting on smoother paper. Rough surface paper is called "rough," a smoother surface but still slightly rough is "cold press," and the smoothest surface is "hot press."

The thickness of commercial watercolor paper varies from 90 lb (190 gsm) to 300 lb (638 gsm). A middle weight is 140 lb (307 gsm). Paper less than 140-lb (307-gsm) thickness will buckle from water-based paint and needs to be stretched before using. Paper that is 140 lb (307 gsm) will show some stress when wet watercolor is applied over large areas but will hold up well when using acrylic paints. Paper that is 300 lb (638 gsm) does not buckle and does not have to be stretched. Papers of lesser quality might be mixed with rag (cotton) and other materials while the better grade (and higher priced) papers are typically 100-percent cotton rag. The quality of paper can make a significant difference in the result. Treat yourself to some high-grade paper for your next art project and you might never return to lighter weight papers. The difference is quite noticeable. When printing on your copier use at least 28-lb (41-gsm) paper for a crisp and clean print.

Bristol is the strongest, most durable, all-purpose drawing paper. It has a hard surface that is heavily sized, polished, and compressed. Bristol is considered a multimedia paper because it can take everything from markers to watercolor. To withstand layers of paint, 140 lb (307 gsm) is a perfect weight.

I just think it's important to be direct and honest with people about why you're photographing them and what you're doing. After all, you are taking some of their soul.

—*MARY ELLEN MARK*

SHOOT

To become a good photographer, you have to take pictures. Snapshots can be engaging if you crop the image to accentuate the focal point. Train your eye to see what works and doesn't work. Be true to what you are trying to convey with your image. With photographs of people, remember the eyes are the windows to the soul.

This digital photograph includes too much distraction on the left side, fighting to get your attention. If the background were plain it would be more compelling.

This balanced crop on both sides makes for a nice head shot.

Cropping this closely into the photograph draws you in and would dominate a piece of art. You would probably not look at anything else on a page. Don't take an image at face value. Try variations on an image you like.

Try printing your images different ways. Lighten the color; make it black and white or sepia-toned. Don't be afraid to reuse your favorite images. In fact, it's fun to see how many ways you can change them into an entirely new piece of art.

Black and white

Sepia

High contrast

STUDY AND CROP

Take a photograph and an index card and place it over different portions of your image. Turn your photo upside down or sideways. Look for design elements. With practice you can teach yourself to observe and look deeper. But most important, take your camera with you everywhere and shoot, shoot, shoot.

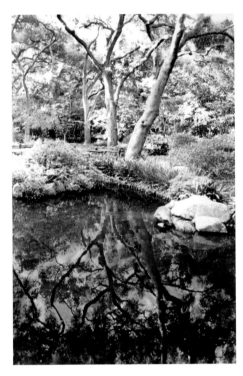

QUIET MIND — Black-and-white photograph, transparent oil paint, pencils

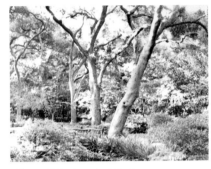

1. Crop of black and white trees

2. Crop of rock in water with some painted trees

3. Crop of painted trees

4. Crop of painted trees upside down

TIPS

• When you make copies from an original photograph to experiment with, don't forget to save each file with a different name.

• Divide your photographs into folders on your computer. Start a library of your favorite photographs so you always have them at your fingertips.

• Cut your photographs up and create a mosaic. Use just part of a photograph, or part of a landscape (see page 102).

• Don't be afraid to try something different that pops into your mind. Some of the best art comes from stepping over the lines of convention.

I'm still learning that there are no mistakes, only discoveries.
—FERNANDO ARAUJO

DISGUISE AND TRANSFORM

What happens when you have your photographs developed and you are less than thrilled with the results? Take the time to go through them and figure out why your pictures don't seem to work. Sometimes you are just disappointed that the background is too busy or that the exposure is less than perfect. Don't despair! Take your photograph and paints and begin altering. You can black out a background and collage it, or stamp onto a lackluster exposure to create a pattern. Work with your images to see whether you can make them come to life. The truth is, with less-than-perfect photographs, a little imagination, and a few materials, you can transform a special moment on celluloid into a lifetime treasure.

UNDERCOVER — Black-and-white photograph

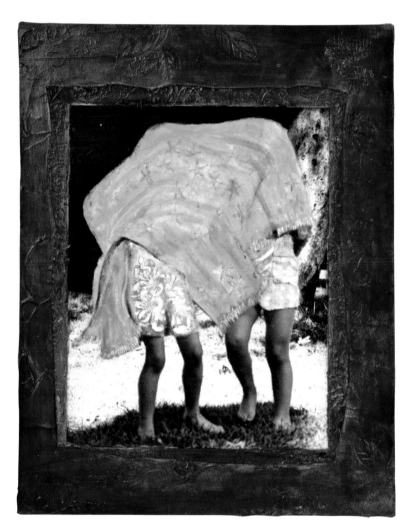

UNDERCOVER — Black-and-white photograph, transparent oil paint, acrylic paint, gesso, rubber stamps

SOFT FOCUS

I try to visit monuments and museums whenever I can to feed the creative muse. I find that re-creations of past events and periods present wonderful photographic opportunities. Using the harsh light of a flash to shoot these artifacts can seem to wipe the sense of history from the subject. If photography is permitted I shoot handheld with my film camera and create a soft-focused photograph. Once I add color with oil or some other muted product, they seem to more accurately capture the reality of those bygone days, and they often find their way into my art.

I never bring a tripod because I like to explore with as little equipment as possible. I tap into my instincts instead of getting weighed down with apparatus. I also like to shoot quickly. I never like the photographs I've shot when I think too much. They seem stilted and the energy seems drained from them. I am passionate about taking photographs, and I let my gut take the lead. I'm a big believer in letting the spirit move you.

TIP

• If the lighting is very low, try balancing your camera on a railing or lean up against a wall for support.

▲ *SOMBRERO* — Black-and-white photograph, transparent oil paint

▲ *CLOSED QUARTERS* Black-and-white photograph, transparent oil paint

FOOD FOR THOUGHT — Black-and-white photograph, transparent oil paint ➤

COLORING
YOUR WORLD

> Some painters transform the sun into a yellow spot, others transform a yellow spot into the sun.
>
> —*PABLO PICASSO*

Take a monochromatic image and paint it. Though we will cover a variety of ways to color, enhance, and manipulate your images, let's begin with one of the oldest and purist methods for hand-coloring: oil paint.

OIL PAINTS AND PHOTOGRAPHY

I call the marriage of oil paints and photography simpatico. Hand-coloring can enhance the spirit, or essence, of a photograph. Using oil paints on photographs offers a unique method for transforming an image. In fact, you can create your own vision of reality. In a digital age, the hand-coloring of photographs is a purist technique that allows the artist a hands-on way to manipulate images. A photograph can be layered with deep, vivid colors or lightly enhanced with a wash or tone to give it a nostalgic feeling. You can bring out the smallest details or disguise them, creating an air of mystery. Your photograph can be realistic or futuristic. You decide and control the look and feel your photograph portrays. There is freedom in the process of coloring with oil paint.

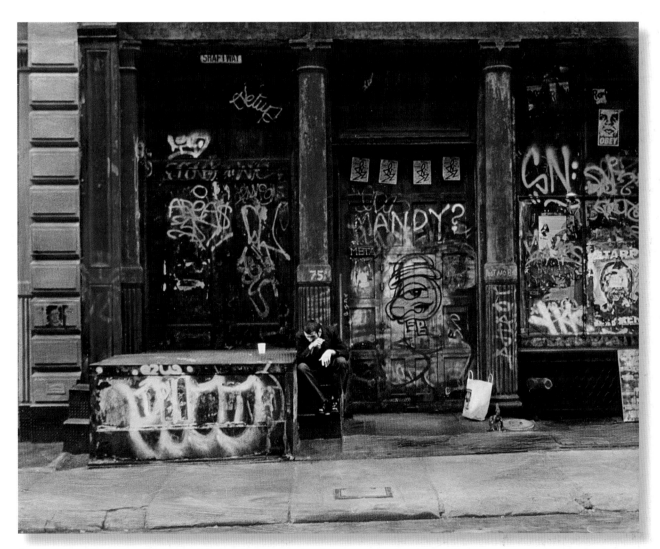

ALONE IN A COLORFUL WORLD — *Black-and-white photograph, transparent oil paint, pencils*

WHAT YOU NEED FOR HAND-PAINTING PHOTOGRAPHS

Marshall's transparent oils or oil paint

Marshall's matte finish or gloss coat spray

Marshall's Marlene

Marshall's P.M. Solution (optional)

Marshall's extender

Marshall's drier (optional)

Marshall's Duolac (optional)

Ranger Cut-n-Dry pen nibs

Oil Color Pencils (Marshall's or Beryl Prismacolor)

palette or dish

100-percent cotton balls

cotton pads

cotton swabs

cotton-wrapped skewers

cotton gloves (optional)

toothpicks

eraser

magnifying glass or loupe

masking tape

Gloves in a Bottle or protective hand cream

(For a glossary of materials and terms, see page 135)

OIL PAINTING ON IMAGES

Project Launch

To hand-color with oils using a traditional approach and professionally made prints, print your images on a matte- or pearl-finish fiber-based paper. If the paper does not have enough "tooth" to take the paint smoothly, treat it with P.M. Solution, a pretreatment for papers that is a mix of medium and turpentine. Alternatively, choose an RC paper on which oil paint moves well on the resin coating, but note that it is not archival. Another option is to print your own photographs on your home printer using the photo paper finish of your choice or the finish recommended for a particular technique.

Always keep a large supply of cotton balls, pads, and cotton swabs close at hand and use fresh ones often. To apply the paint to the surface of the photograph, use a toothpick, then move the color around with your fingers, brushes, or cotton balls. I prefer using my fingers, which gives me a tactile connection to my photographic artwork. If you want to use your fingers, apply a layer of Gloves in a Bottle, which acts as an invisible pair of gloves, or hand lotion to protect your hands before painting. Baby wipes are perfect for cleaning your hands when you change colors. Find the method that works for you; there is no right or wrong way when creating your own art.

When you begin painting, try to work intuitively. Dispel any fear of making a mistake and just let the image speak to you. If you have trouble deciding what to do, think back to when you took the photograph and remember the quality of light playing on the subject, and how you felt at the time. That memory can affect the mood that the image conveys to you later and can influence the colors that may express those feelings.

Walk away from a piece you are working on and go back to it later or the next day. Seeing an image with fresh eyes often shows you the direction it needs to take. You may find that you will know instinctively what needs to be added or taken away, or you may find, to your pleasure, that the image feels perfectly complete.

The best way to learn is to experiment. Pull out some of those photographs you have stored away and play.

TIMELINE

Daniel Davis, Jr. patents a method for coloring daguerreotypes through electroplating.

1842

1840s

The era of the daguerreotype; hand-coloring is used to enhance the realism of photographic images.

1860s

The practice of hand-coloring becomes a respected and refined art form in Japan.

The important thing is not the camera but the eye.
—ALFRED EISENSTAEDT

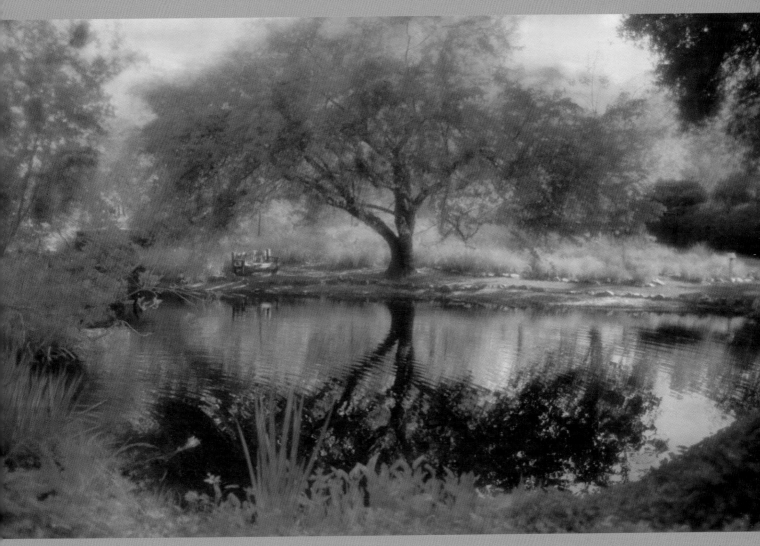

GUARDIAN OF THE WATERS — Black-and-white photograph, transparent oil paint

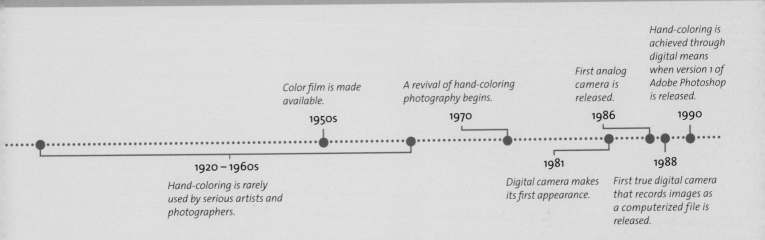

Color film is made available.

1950s

A revival of hand-coloring photography begins.

1970

First analog camera is released.

1986

Hand-coloring is achieved through digital means when version 1 of Adobe Photoshop is released.

1990

1920 – 1960s

Hand-coloring is rarely used by serious artists and photographers.

1981

Digital camera makes its first appearance.

1988

First true digital camera that records images as a computerized file is released.

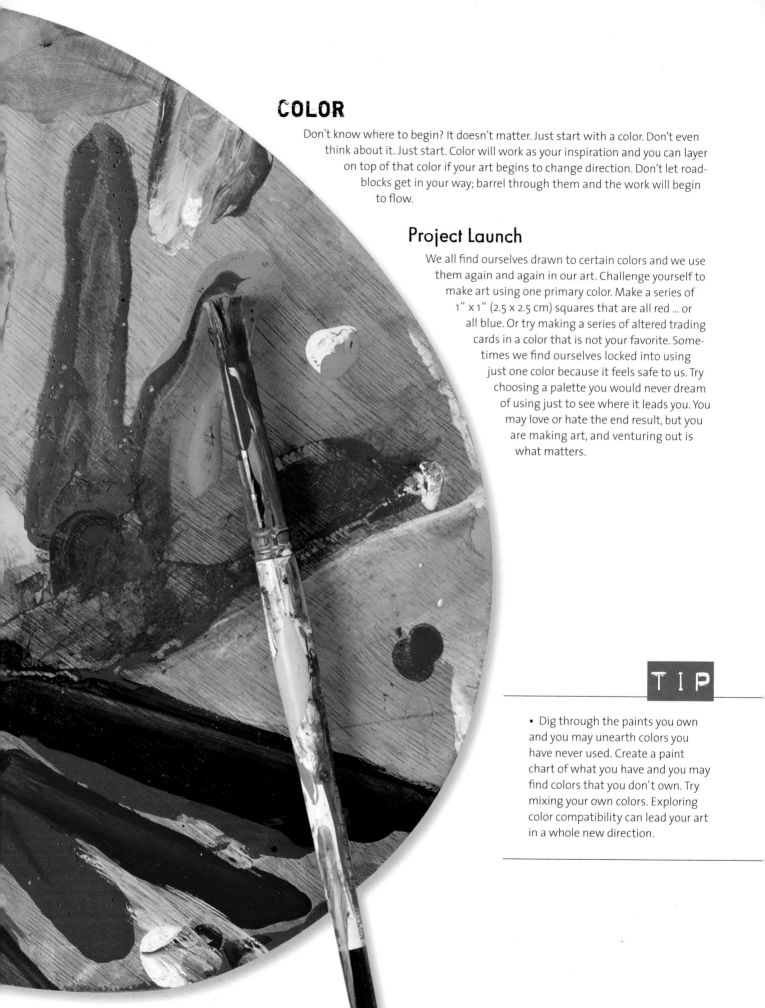

COLOR

Don't know where to begin? It doesn't matter. Just start with a color. Don't even think about it. Just start. Color will work as your inspiration and you can layer on top of that color if your art begins to change direction. Don't let roadblocks get in your way; barrel through them and the work will begin to flow.

Project Launch

We all find ourselves drawn to certain colors and we use them again and again in our art. Challenge yourself to make art using one primary color. Make a series of 1" x 1" (2.5 x 2.5 cm) squares that are all red ... or all blue. Or try making a series of altered trading cards in a color that is not your favorite. Sometimes we find ourselves locked into using just one color because it feels safe to us. Try choosing a palette you would never dream of using just to see where it leads you. You may love or hate the end result, but you are making art, and venturing out is what matters.

TIP

• Dig through the paints you own and you may unearth colors you have never used. Create a paint chart of what you have and you may find colors that you don't own. Try mixing your own colors. Exploring color compatibility can lead your art in a whole new direction.

Why do two colors, put one next to the other, sing? Can one really explain this? No. Just as one can never learn how to paint.

—*PABLO PICASSO*

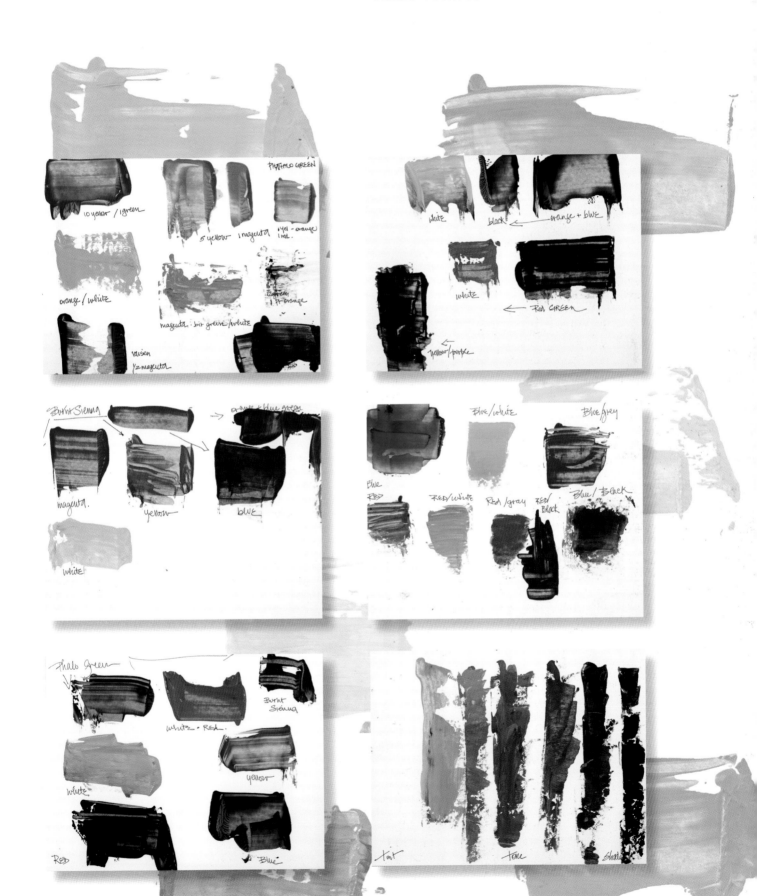

Mood

Different moods can be achieved by painting with different colors. The feeling that the sun is setting in this picture is achieved by layers of oil paint applied on top of one another. White titanium opaque paint is added over and under other colors to achieve the highlighting effect of light shining through the clouds.

When painting an expansive area, "wash" the photograph with color, then add other shades to different parts and let the colors overlap. Forget the adage "color between the lines" if you want your photograph to have a more realistic look. When you paint within the lines, ridges develop and create what is called "edge halo," which produces a more unnatural but interesting finish.

TIP

• If you begin painting from the top to the bottom, you avoid smearing what you have already painted.

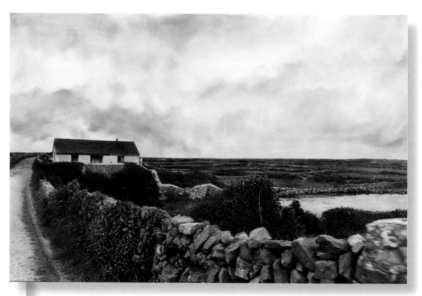

THE ROAD HOME #1 — *Black-and-white photograph, transparent oil paint*

THE ROAD HOME — *Black-and-white photograph before hand-painting*

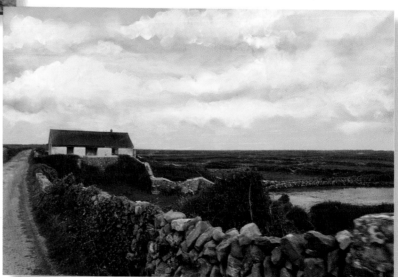

THE ROAD HOME #2 — *Black-and-white photograph, transparent oil paint*

Sliding the Paint

Sliding the paint with your fingers can create different textures on the photograph. By letting the first coat of paint almost dry, it can be dragged and encouraged to separate. A dimensional feel is created, which adds interest to a wall or vast space. This process is all about learning through experimentation. You can achieve some of your most interesting effects through what you may have initially considered a mistake.

- It is best not to paint with oil directly out of the tube, as the oil separates and rises to the top. Put a small amount on a palette or plate and mix with your fingers or a brush before applying. Remember, a little paint goes a long way.

DAY'S END — *Black-and-white photograph, transparent oil paint*

PIT STOP — *Black-and-white photograph, transparent oil paint*

Impasto Painting

Impasto is a thick application of paint in a work of art. Applied with a palette knife or other tool, impasto allows the artist to create irresistible sculptural effects, and the rough surface texture contributes to a fascinating appearance of broken color. Impasto paint was used in the seventeenth century to reflect light and add expressiveness to a painting.

TIP

• If you are not happy with the results you have after painting a photograph, you can use Marshall's Marlene liquid to wipe the oil away. You can also clean the paint off an entire photograph by applying P.M. Solution, but if you wait too long, some oil pigments may stain. If you remove the paint too many times however, eventually the paper will not be able to hold color.

CATALINA SEAS — Black-and-white photograph, transparent oil paint

▲ Even though these colors may be completely unrealistic, applying the oil paint in this heavy manner can create an imaginary, dreamy scene.

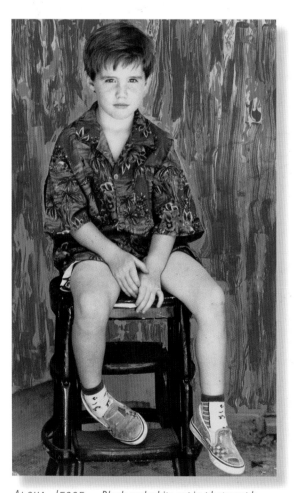

ALOHA JESSE — Black-and-white sepia photograph, tube oil paint

◀ Interpret a photograph any way you choose. A chopstick was used to apply this thick oil paint on a sepia photograph. The Hawaiian shirt could have been painted to make a colorful statement, but by painting the back wall with the impasto method the figure pops out.

Soft Tones

Lightly painted soft tones add a quiet, intimate feel to a photograph. Use transparent oil colors for this effect. If you feel the color is too dense, it can be rubbed lightly with a cotton ball, or you can mix in a little paint extender, which will thin and spread the paint, lightening the color.

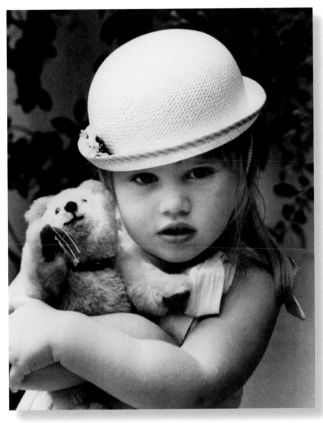

BECCA'S BEAR — Black-and-white photograph, transparent oil paint

TIPS

- Cotton swabs are invaluable for wiping away color when it extends beyond where you want it to go.

- For painting small areas, wrap cotton around a skewer, use Cut-n-Dry pen nibs, or choose to use oil pencils instead.

THIRTEEN — Black-and-white sepia photograph, transparent oil paint

NOTEWORTHY

- I always leave some areas in my photographs without paint. I like the original tone of the photograph showing through. For this sepia photograph, only selected areas are colored: the foliage and the soft blue sky. Often, less is more if you want an image to stand on its own merit.

ACRYLICS

The best acrylic paints have more pigments, which means more color. Today there are many brands to choose from that offer high-quality acrylic paints with exceptional vibrancy, clarity, and tinting strength. Always use high-grade acrylic paints so they will be permanent, will maintain flexibility, and won't yellow over time.

One characteristic of acrylic paints is how fast they dry. Some artists love this, others don't. When painting with acrylic on photographs, the colors are easy to mix and duplicate — and brushstrokes can be smooth or textured depending on the effect you desire.

When printing your own photographs and painting with acrylics on matte photo paper, use glaze instead of water to make your paint more fluid. Too much water may remove the image from the paper.

◄ This tree photograph was printed on semigloss paper and painted with a fine-tipped paintbrush. For painting areas like the leaves, dip your finger in water and then the paint to create a wash to cover the tree leaves.

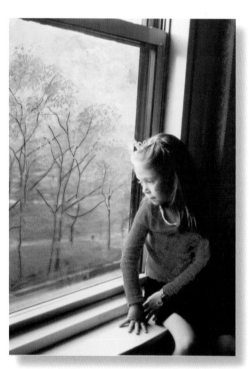

◄ Remember that you will need to paint quickly when using acrylics, removing hard edges immediately if you want them blended. The paint on this photograph of the girl at the window was printed on matte photo paper, and was challenging to blend but resulted in a painterly look.

WHIPPED — Black-and-white photograph on semigloss photo paper, acrylic paint

BIRTHDAY GIRL OVERLOOKING CENTRAL PARK — Black-and-white photograph on matte photo paper, acrylic paint

TIMELINE

Chemist Otto Röhm makes synthetic acrylic resin in a German laboratory.

1901

Leonard Bocour, founder of Bocour Artists Colors, Inc. (now Golden Artist Colors) offers limited range of acrylic paints marketed under the name Magna.

1949

1930s

DuPont brings acrylic resin into American commercial production.

1953

First true acrylic paints are introduced by Röhm and Haas as interior wall paints.

PIGMENT PAINTS

This background was painted with pigment paints found in bags at a flea market. Pure pigment paint was used by Native Americans, and the colors are very rich. They are easy to use when mixed with water, but I was told also they can be mixed with lard. A wide variety of pigment powders, including metallics, pearlescents, and iridescents, are now available and will add punch to your altered images with their light-reflecting ingredients.

OBSERVER — Black-and-white photograph hand-painted with oils, pigment paints, crackle gel, rakusui-shi paper, ephemera

TIPS

• When you buy acrylic paints or inks, take a drop of the paint and put it on the top of the lid. That way you can see what color it is, without digging through all the bottles.

• Acrylic paintings can undergo chemical changes as they age, but when a painting is kept indoors these changes that cause hardening are very slow. Always add a non-yellowing varnish to protect your artwork.

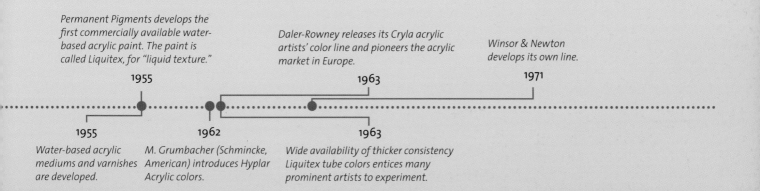

Permanent Pigments develops the first commercially available water-based acrylic paint. The paint is called Liquitex, for "liquid texture."

1955

Daler-Rowney releases its Cryla acrylic artists' color line and pioneers the acrylic market in Europe.

1963

Winsor & Newton develops its own line.

1971

1955

Water-based acrylic mediums and varnishes are developed.

1962

M. Grumbacher (Schmincke, American) introduces Hyplar Acrylic colors.

1963

Wide availability of thicker consistency Liquitex tube colors entices many prominent artists to experiment.

DESIGN

DESIGNS IN OIL

Take the leap to expand and experiment. A great photograph can stand on its own merit, but there is another avenue for you to pursue with your photographs by using design elements, artistic materials, and a sprinkle of adventure. Take your imagery into an altered state of bliss.

Stamping into Oil

The photograph below is a black-and-white image heavily hand-painted with oils. Celtic symbol stamps were stamped into the oil paint while it was still wet, removing some of the paint, and leaving an impression. The sky reveals shades of gray from the original photograph through the stamped impressions.

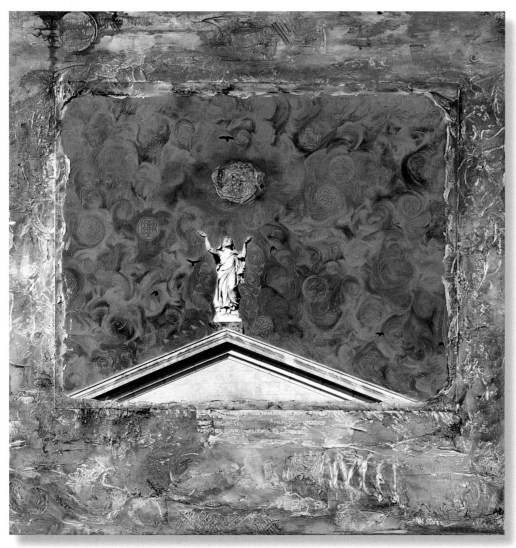

HEAVEN BOUND #1 — Black-and-white photograph, heavy transparent oil paint, rubber stamps, molding paste, acrylic paint, metallic effects paint

Stamping onto Oil

The same photograph was painted in sections with an ochre oil paint and left to dry for a couple of days. A heavy layer of blue oil paint was added to the entire photograph and left to dry completely for several weeks. Using Marshall's Marlene paint remover and a bag of cotton balls, the paint was lifted from the photograph, leaving a paint-stained background. The scrolled design was stamped onto the photograph with Clear Perfect Medium Stamp Pad. The luminous color was then applied with a soft brush dipped in Ranger Perfect Pearls pigment powders and dusted over the surface of the stamped image. A soft larger whisk brush was used to remove any excess Perfect Pearls. A fine misting with water set the pigments.

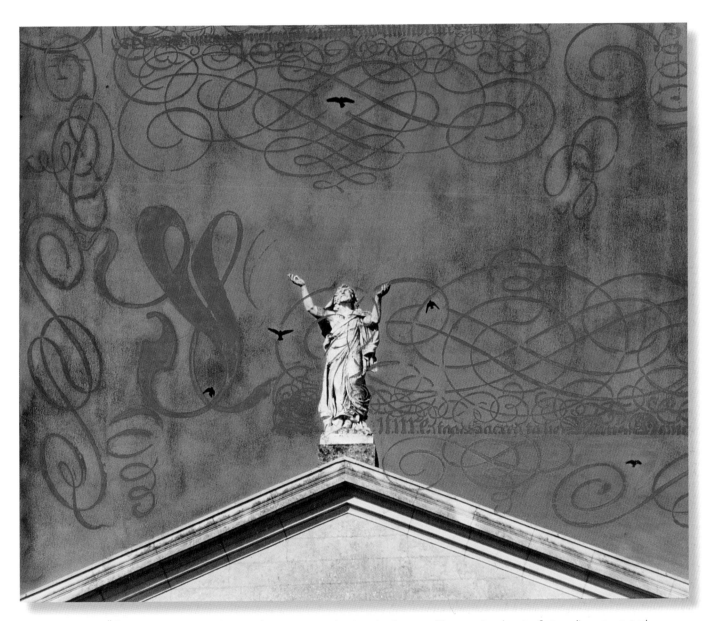

HEAVEN BOUND #2— *Black-and-white photograph, transparent oil paint wiped away, rubber stamps, clear perfect medium stamp pad, Perfect Pearls pigment powders*

These examples show some stamping variations. Cottage walls are a perfect canvas for stamping textures into or onto the surface.

Project Launch

Choose a stamp design and a permanent dye ink stamp pad so the ink won't smear if you layer paint colors over it. Pat the ink pad onto the surface of your stamp instead of the other way around. This prevents the ink from touching areas of the stamp pad you don't want to print. It's a good idea to test your stamp out on some paper first to see whether you have adequately covered it with ink and how much pressure you want to apply for a clean image. Use steady, consistent pressure. To stamp onto your photograph, apply dye ink to the stamp surface and press down firmly. Resist the temptation to rock the stamp unless you want the lines to look uneven or splayed. Always clean your stamps after using them with a baby wipe or stamp cleaner.

TIP

• When stamping onto or into black-and-white photographs with oil paint, you have a little more time because oil paint does not dry as quickly.

Black–and-white photo stamped *on*to:

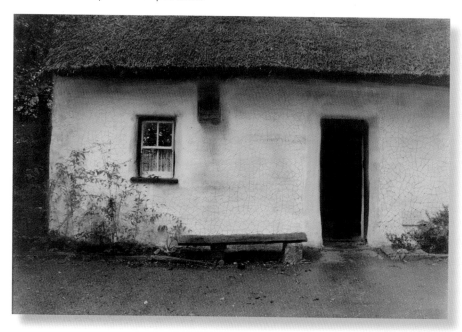

CRACKLE COTTAGE — *Black-and-white photograph hand-painted with oils, rubber stamp, dye ink pad*

Black–and-white photo stamped *in*to:

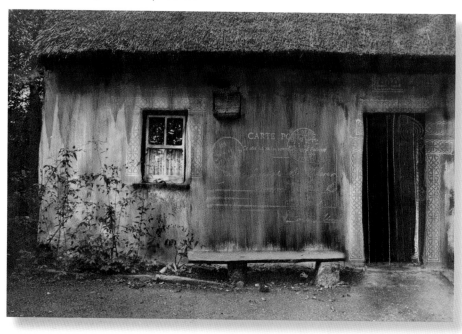

LETTERS HOME COTTAGE — *Black-and-white print from a color photograph hand-painted with oils, rubber stamp*

Color photo stamped *onto:*

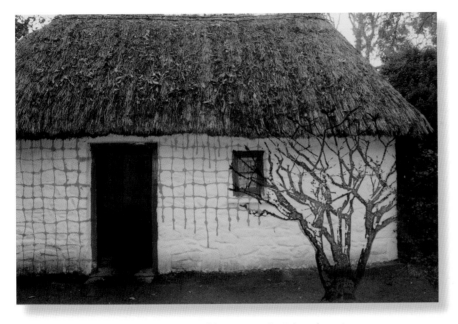

GRID COTTAGE — *Color photograph, rubber stamp, dye ink pad*

TIPS

• When you stamp onto color photographs using a dye ink pad it dries very quickly, so have your stamps ready to use before applying your ink or paints.

• After you have stamped into or onto your images, protect your photographs with a matte or gloss spray.

• Stamp carefully if you are stamping with a permanent stamp pad ink. It is difficult to remove from color photographs on a glossy surface and may damage the surface.

Color photo stamped *into:*

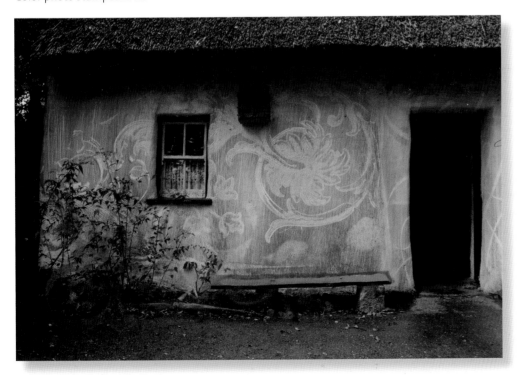

FLEUR COTTAGE — *Color photograph, rubber stamp, oil paint*

WASH

Methods for hand-coloring photographs abound! In this section, we explore alternatives to oil paint and experiment with this wide array of materials and color effects achieved through their use.

WATERCOLOR CRAYONS

Watercolor crayons or sticks produce a different look when used on different substrates. On photographic paper you can use the sticks like a crayon and add water to blend. The color floats over the top of the image because of the paper coating. Excess water completely moves the color over and around the surface, without it sinking in, creating an interesting effect.

When working with a black-and-white photograph printed on watercolor paper, apply the watercolor sticks the same way. With the addition of water, the paper absorbs the color, which can be manipulated to create a truly blended image. As the examples below show, the same crayon colors react differently on each substance.

TIP

• Watercolor crayons are wax-based and water soluble. Staining is characteristic of watercolor paints, but stains can be lightened or removed almost entirely when rewetted by "lifting" with a wet brush, paper towel, tissue, or sponge. Water-based colors will not adhere to oil-based colors.

WAND FEATHER #1 — Black-and-white photograph on photographic paper, watercolor crayons

WAND FEATHER #2 — Black-and-white photograph on watercolor paper, watercolor crayons

Lyra Aquacolor wax crayons come in a wide range of colors that blend nicely on photographic paper. Once you add water, the color begins to wash away and you need to work it with your paintbrush. Let each layer dry before applying another one, and begin to build layers.

WATERCOLOR EXTENSIONS

Use watercolor paints and your imagination to stretch your art and extend your images.

The Process of Granulation

Granulation of a watercolor paint sometimes occurs when using heavier (denser) pigments. With a few exceptions, these paints contain one or more inorganic pigments with metal elements that cause them to separate and lay, like granules, on the surface. To increase this granulation effect, add distilled water to your watercolor paint. The pigments drop out of the binder water solution and settle into the valleys of the watercolor paper, creating a marvelous conjunction of dark to light.

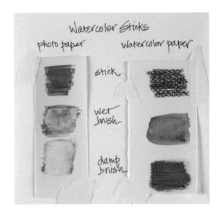

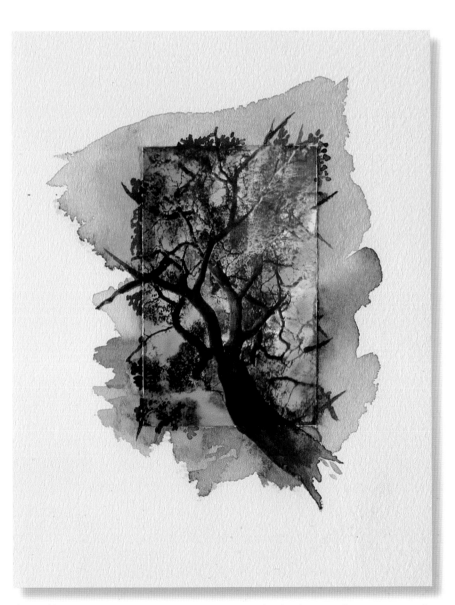

LOOK UP — Black-and-white photograph hand-painted with oils, watercolor paper, watercolors

NOTEWORTHY

- The broad term for water-based painting media is watermedia. The term watercolor often refers to traditional transparent watercolor or gouache, which is an opaque form of the same paint.

Extending Your Photographs Project Launch

Play with watercolors to extend your photographs beyond the edge of the image. This hand-painted photograph was printed on card stock and adhered to a watercolor paper. Three colors of watercolor paints were washed over the edges of the photograph. When it was dry, a fine-tipped watercolor brush extended the limbs and tree trunk beyond the original. There are many ways this technique can be used to extend an image. Paint in what lies beyond the actual border of the photograph, or simply create it with your imagination. You can also print your image on watercolor paper and extend your photographs with watercolor paint.

RUB

When I discovered oil pastels, I fell in love with them. Rubbing them into your photographs or onto your art surface can produce magical results.

OIL PASTELS

Oil pastels are a dust-free medium that have the qualities of oil paint and come in an easy-to-apply stick form. Color your entire art piece with oil pastels or rub them into your art to add and deepen color, accent edges, and fill in distressed areas. Oil pastels are invaluable in creating dimension and adding a finishing touch that can brighten and make the elements of an art piece cohesive.

Made from pure concentrated pigment, safflower oil, and a high-quality mineral wax, oil pastels can be used alone or in combination with tube oil paints. They can be used directly or you can mix colors with your fingers or a rag. These creamy, lightfast sticks have the consistency of a lipstick and are a bit messy to work with; however, the pure pigment colors and the results you can achieve from them are well worth getting your fingers a bit dirty. Oil pastels will repel water-based materials and color in the surrounding area, so use them to create resists for watercolor, gouache, ink, or light acrylic washes. Draw on almost any surface with them as well: canvas, wood, ceramic, plaster, metal, plastic, glass, and photographs.

TIPS

• Try using a tortillions (also known as a stomp or stump) to blend your pastels. You can add and blend color or take it away. Use the tip to color tight spaces.

• Clean your stump by rubbing the tip and sides on an emery board, or fine grit sandpaper, to remove color and sharpen. Never use them in a pencil sharpener.

• Cut 'n Dry Nibs by Ranger are similar to tortillions and can be used with dye inks reinkers and water-based solvents.

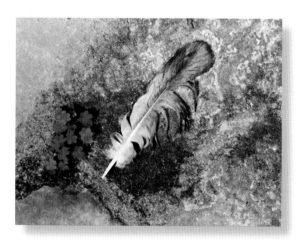

LUCKY FEATHER — Black-and-white photograph hand-painted with oil pastels

TIMELINE

Invention of the portable tin tube allows oil paints with a new range of chemical pigments to be packaged. Jean, Renoir's son, wrote, "easily transportable paints in tubes led us to paint directly from nature. Without tube paint there would have been no Cezanne, no Monet, no Sisley, no Pissarro, none of what the critics had to call impressionism."

1901

Pablo Picasso asks Henri Sennelier to create a completely new medium that has the qualities of oil paint and soft pastel in an easy-to-apply stick form. Picasso tells Henri, "I want a colored pastel that I can paint on anything ... wood, paper, canvas, or metal without having to prepare or prime the surface." This collaboration gave birth to Sennelier Oil Pastels.

1949

1450

In Italy, pigments mixed with gum Arabic are formed into pastels.

1925

Sakura's Cray-Pas are introduced to Japanese children and considered the earliest "oil pastel."

1966

Paint sticks become commercially available.

PAINT STICKS

Paint sticks are a solid oil paint in stick form that dry and reseal, creating a hard outer skin that can be cut, peeled, or rubbed off before using. Made from highly refined drying oils blended with fine pigments, they are molded into sticks that liquefy and flow onto a painting surface when applied. Paint sticks require no mixing, no palette, and no brush, and are a favorite for quick sketching. They are somewhat drier than oil paints from a tube and can be difficult to move with a brush without the addition of a fluid medium. Because they are large, they work well on bigger pieces of art and are great for rubbing into molding pastes and textured elements.

Sgraffito

Sgraffito is a technique of ornamentation in which a surface layer of paint, plaster, slip, or the like is incised to reveal a ground of contrasting color. This sample photograph was taken when the light was pouring in through the barn window, creating a shadow pattern on Sunny's nose. Print an image on watercolor paper and then paint it with oil pastels by rubbing them into the shadows. Here I used blue and ochre to color the area around the photograph. Apply a thick layer of black oil pastel over the top, then scrape and manipulate it with the scissor tip to reveal the undertone. Other sgraffito effects can be created by using a stylus or pointed objects to scratch into the layers.

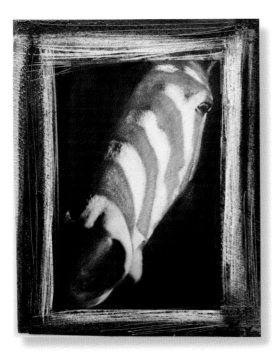

original photograph

FAUX ZEBRA — *Black-and-white photograph hand painted with oil sticks*

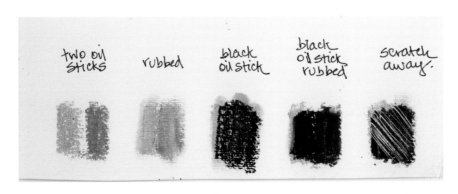

TIPS

- If you wish to obtain a wash, dilute the oil pastel with water or turpentine.

- Oil pastels need to be treated with a fixative. Although they are quite lightfast and resistant to humidity and cracking, oil pastels do not ever totally dry; dust may stick to the painting, and contact with any object may damage its surface.

- Because oil pastels are nontoxic and have no fumes they are the perfect medium to take with you when you travel.

- Paint sticks won't rub off or dry out. They stay moist and have an indefinite shelf life because the sticks reseal themselves. This film can be removed by peeling it away, rubbing it off gently with a cloth, or paring it with a knife.

OIL PENCILS

You can use pencils over oil paint to deepen the color, highlight, and enhance the fine details. Be sure to use a light touch when coloring with pencils so you don't scratch the surface of the print. You will need a pencil that is very soft so it can be blended. To soften the tip of an oil pencil you can dip the tip in mineral spirits before using it. If you find you have left pencil strokes on your image and want them to soften, use a cotton ball dipped in mineral spirits or a colorless marker for blending.

◄ *A RIVER RUNS THROUGH IT* — Black-and-white photograph, transparent oil paint, oil pencils

TIMELINE

Graphite is first discovered near Keswick, England, by an unknown person.
1564

Friedrich Staedtler creates the first wood-cased graphite pencil.
1662

Charles Marie de la Condamine is the first European to bring back the natural substance called "India" rubber.
1736

Edward Naime is credited with the creation of the first eraser.
1770

> A photograph is usually looked at—seldom looked into.
> —ANSEL ADAMS

WHERE'S MY SHOVEL? — Black-and-white photograph, transparent oil paint, pencils

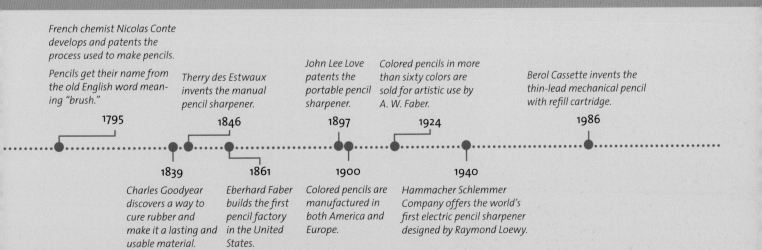

French chemist Nicolas Conte develops and patents the process used to make pencils.

Pencils get their name from the old English word meaning "brush."

1795

Charles Goodyear discovers a way to cure rubber and make it a lasting and usable material.

1839

Therry des Estwaux invents the manual pencil sharpener.

1846

Eberhard Faber builds the first pencil factory in the United States.

1861

John Lee Love patents the portable pencil sharpener.

1897

Colored pencils are manufactured in both America and Europe.

1900

Colored pencils in more than sixty colors are sold for artistic use by A. W. Faber.

1924

Hammacher Schlemmer Company offers the world's first electric pencil sharpener designed by Raymond Loewy.

1940

Berol Cassette invents the thin-lead mechanical pencil with refill cartridge.

1986

BLEND

Don't just think of markers when you need to highlight your book or keep your children busy. Markers have leapt into the world of altered imagery with their versatility and splendid variety of colors.

MARKERS

Of all hand-coloring methods, markers can create the most intense colors. They contain a reservoir of soluble ink that moves through a felt or nylon tip to your art. There are markers with broad, hard nibs or flexible brush tips, fine- and medium-tip markers, and some that have three or four choices of nibs in one pen. Unlike the markers some of us remember using as children, markers today are mostly odorless and water-based and can be layered to create new colors.

When painting photographs with markers, remember that some of them are permanent, and once the color has been laid down it is impossible to erase. Others allow a little lead time to move or smoosh the color around for blending. There are also blending markers available to move the hard edges or lighten them. Experiment on several photographic paper surfaces; the effects of a particular marker will vary. With a large selection of colors available, the ability to create realistic colors or surreal effects is at your fingertips.

A PAILFUL — Black-and-white photograph hand-painted with markers, pigment pens

TIMELINE

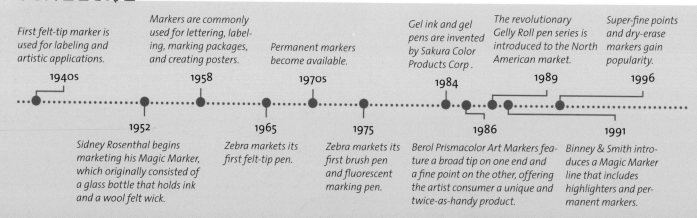

1940s — *First felt-tip marker is used for labeling and artistic applications.*

1952 — *Sidney Rosenthal begins marketing his Magic Marker, which originally consisted of a glass bottle that holds ink and a wool felt wick.*

1958 — *Markers are commonly used for lettering, labeling, marking packages, and creating posters.*

1965 — *Zebra markets its first felt-tip pen.*

1970s — *Permanent markers become available.*

1975 — *Zebra markets its first brush pen and fluorescent marking pen.*

1984 — *Gel ink and gel pens are invented by Sakura Color Products Corp.*

1986 — *Berol Prismacolor Art Markers feature a broad tip on one end and a fine point on the other, offering the artist consumer a unique and twice-as-handy product.*

1989 — *The revolutionary Gelly Roll pen series is introduced to the North American market.*

1991 — *Binney & Smith introduces a Magic Marker line that includes highlighters and permanent markers.*

1996 — *Super-fine points and dry-erase markers gain popularity.*

Markers used on photo paper can produce dynamic results. The details of a black-and-white photograph show through the translucent inks. This photograph was printed on glossy photo paper and colored with a variety of markers containing both permanent and solvent-based inks.

Poster paint markers are another great tool to have in your art box. They are water-based and fade-resistant. The colors are opaque and add punch when used to highlight an image or to write text. I particularly like white and black to outline and to add accents.

A REFLECTION ON YOU #1 — Black-and-white photograph

A REFLECTION ON YOU #2 — Black-and-white photograph printed on glossy photo paper, hand-painted with markers, white pen

Photograph: A picture painted by the sun without instruction in art.

—AMBROSE BIERCE

ANTIQUE

Antiquated heirlooms and vintage relics are words that conjure up a feeling of nostalgia and memories. Using antiqued imagery in your art provides a timeless appeal.

WALNUT INK

This finely pigmented water-based ink works well with either a brush or a dip pen. In washes, it handles like a watercolor and can create a wide range of effects. Its rich color resembles traditional walnut-based inks and can add age and distress to your images or the substrate around them.

Walnut ink is composed of crystals made by boiling black walnuts and their hulls. It is then strained and distilled to remove the water. Buy the crystals and make your own strengths of ink. The more water you add, the lighter the color will be. Layer coats of ink to achieve a deep rich color. You can also buy walnut ink already mixed, but it's an advantage to have the ability to get the exact shade you want to achieve.

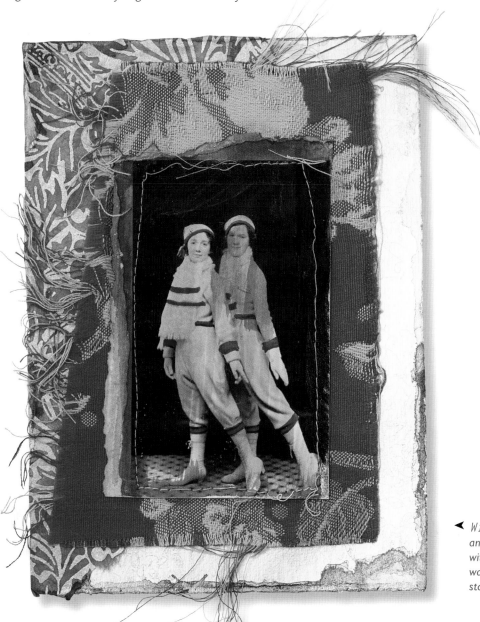

◄ WINTER DANCE — Vintage black-and-white photograph hand-painted with markers and walnut ink color wash, stitched on French fabric, gold stamped paper

The versatility of walnut ink is vast. Dip the corners of your art in the ink to create a vintage look. Brush the edges with a light mixture of walnut ink to soften straight lines. Experiment with different application techniques; you can dip, drip, wash, and splatter to add depth and interest to your art.

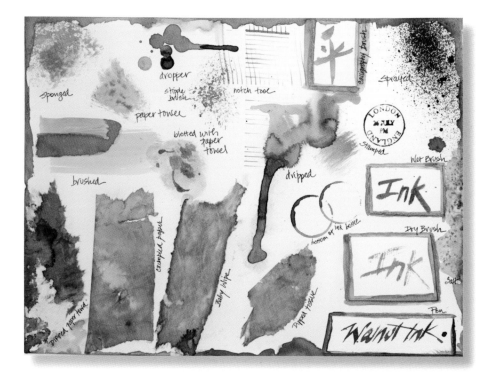

TIPS

• Use a sponge or paper towel to dab the ink.

• Pour the ink into a resealable bag and place the item you want to stain into the bag, letting it absorb the ink until it's the color you desire. Remove the item and lay flat on a paper towel to dry.

• Fill your paintbrush with watery walnut ink or use a stipple brush to transfer the walnut ink onto your paper.

• Put the walnut ink in a spray bottle and squirt it onto your paper to get a spattered design.

• Wet your paper with walnut ink, then sprinkle salt on the paper.

• Crumple your paper before you ink it. Crumpling breaks the paper fibers and will absorb the ink into the cracks.

• Use rubber stamps or experiment with different stamping objects.

• Dip different pens and implements into the ink for writing.

• Sprinkle a few of the dry ink crystals on your paper, then spray with plain water.

• Write with water over a dried wash of walnut ink for an unusual effect.

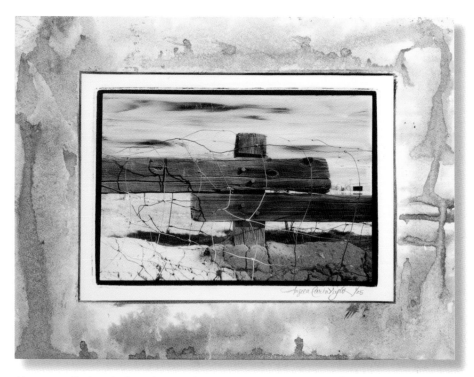

WIRED — *Black-and-white photograph hand-painted with oils, walnut-inked mat*

FADE AND ENHANCE

The varied applications and changeable functions characteristic of gesso make it one of my favorite products to play and experiment with. Give your photos a thin wash of gesso and watch them transform.

GESSO

Gesso, the Italian word for chalk, akin to the Greek word gypsum, is a five-letter word for versatility.

A mixture of glue and either chalk or plaster of paris, gesso is a ready-made liquid ground formulated to cover surfaces and provide tooth so paint will adhere. Besides its traditional use as a priming base for canvas, there is so much more that gesso can do. Frequently seen as a finished part of altered art, it can be built up or molded into relief designs, carved, sprayed, or applied with a brush, roller, or trowel.

To avoid cracking, apply gesso in thin layers. Although one coat of gesso will provide good adhesion, it can leave some uncovered areas. Apply at least two coats of gesso to any surface when you are planning to paint on top of it, especially on canvas or linen. A second coat will bond with the first layer and even out the surface. More layers can be added for an increasingly smoother surface.

TIPS

• Acrylic gesso is easy to clean up with water.

• Gel or gel medium can be added to gesso to decrease the tooth and absorbency of paint.

• Gesso can be applied with a palette knife or similar tool to create a texture with the application. A hake brush, which is handmade in Japan, is a good brush for applying gesso, paste, or varnish.

• Pre-gessoed canvases can be obtained commercially, but they are smooth and less economical than gessoing your own substrate.

Project Launch

For an effect like the one shown, apply two coats of gesso to a canvas board, making impressions in the last coat. When dry, paint over it with a thin wash of acrylic paint. Attach the black-and-white photograph with matte medium, and wash over the image with a watered-down solution of gesso. With a dab of pink paint, add smudges of color with your fingers. Randomly glue pieces of paper and when completely dry, peel them away to create distressed areas.

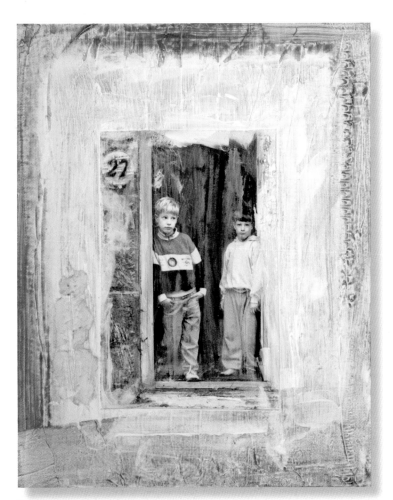

WHIPPERSNAPPERS — Black-and-white photograph, gesso wash, acrylic paint

Gold Gesso

Approach your project in a different way by starting with a colored gesso. If you prefer not to buy a premixed colored gesso, add your own acrylic paint colors to white. Gold gesso is a very high-grade acrylic emulsion that allows optimal flexibility and durability. It is fantastic for layering and adds a sheen that can be muted or enhanced by using a matte or gloss varnish.

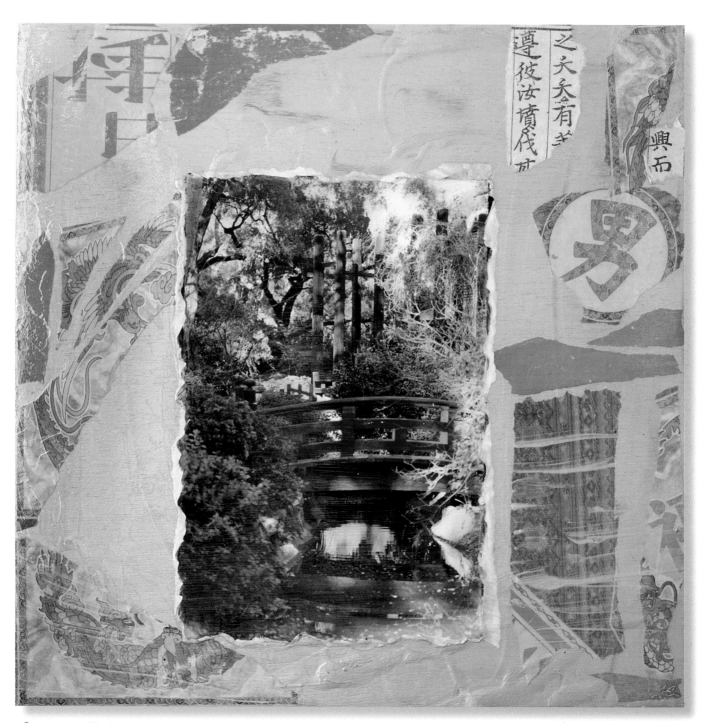

BRIDGES — *Black-and-white hand-painted photograph, gold gesso, joss paper*

> If you are photographing in color you show the color of their clothes—if you use black and white you will show the color of their soul.
>
> —*ANONYMOUS*

CONTRAST

By themselves or combined, the contrast between black and white can set a dramatic stage for your photography.

WHITE

You can stamp a pattern with rubber stamps into white gesso on your canvas and then take it one step further. Carry that stamping onto your black-and-white photographs and use a white pen to write or create designs. This is one more way to integrate your photograph with your substrate.

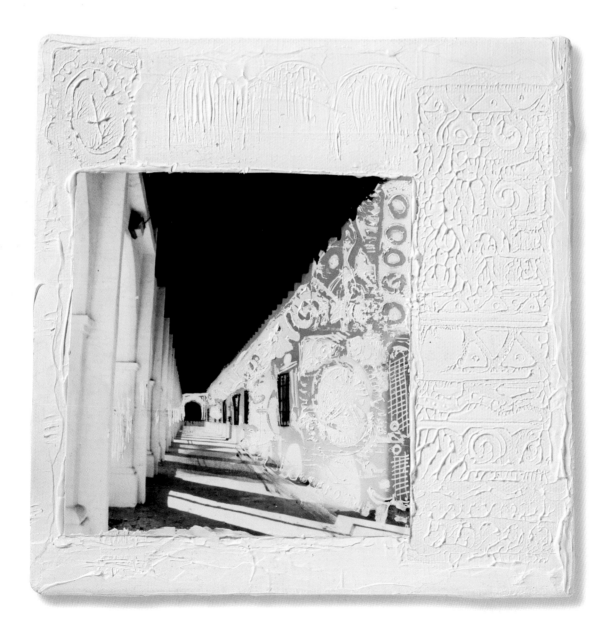

LIGHT SHOW — Black-and-white photograph, white gesso, rubber stamps, white pen

BLACK

Black gesso makes a terrific base for canvas, wood, or journal pages. Because of its chalky character, black gesso is an ideal medium to use in combination with bleach, chalk paint, and light colored gel pens for dramatic effects.

Project Launch

Prepare your substrate with black gesso, and set it aside to dry. Photocopy or find the image you wish to use. (I prefer a matte photograph paper with these materials.) Sand the sides and corners of the image, and then add walnut or distress inks (see page 54). Glue material to your canvas and use a chalk paint pen and white pen to decorate and add details.

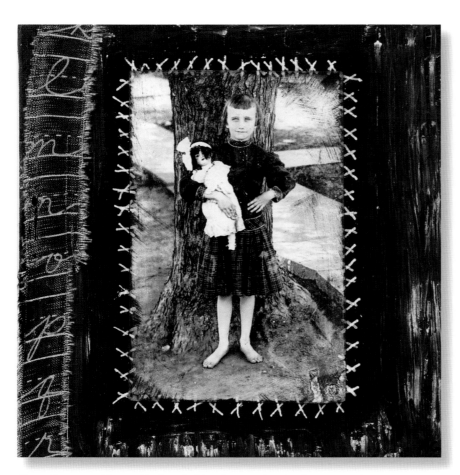

POOR DOLLY — Vintage black-and-white photograph printed on matte photo paper, black gesso, fabric, white pen, chalk paint pen, black gel pen, India ink

T I P

• There are pens available that write on virtually any surface. Gelly Roll Glaze and Soufflé pens are perfect for the application of writing on photographs, acrylic, or other painted surfaces. If you write slowly with these pens you will achieve a more embossed look. Different nib sizes can be used for anything from detail work to bold strokes. Water-based pens work the best with mixed-media art. Painting over them will integrate your words into your artwork.

Only those who attempt the absurd will achieve the impossible.
I think it's in my basement... let me go upstairs and check.
—M.C. ESCHER

TINT

INK

I love working with Ranger Adirondack Alcohol Inks and Distress Ink Pads. When I first discovered them, I was immediately engaged by the vibrant intensity of their colors and vast array of uses for coloring and adding texture.

TIP

• Ink stains fingers and clothing, so wear gloves or protective hand cream and an apron when you work with it.

DWELLING — Dripped alcohol inks

SCRAMBLE — Painted with paper towel, inks

SHANTY — Alcohol inks and water applied with foam pad

ABODE — Sprayed with an ink color wash and scratched

ALL ABOUT INKS

Archival inks are fade- and water-resistant, dye-based ink. They dry on all types of paper like a dye ink and won't smear when brushed over with watercolors and water-based markers.

Dye inks are thinner in consistency and transparent; however, they may smear when brushed over with watercolors and water-based markers. Dye inks' thinner consistency makes them more concentrated and they appear darker in the stamp pad. They dissolve in solution, blend well, and dry quickly on all types of paper.

Pigment inks are thick and opaque and appear similar in the stamp pad to the color they stamp out. Pigment inks are also more light- and heat-stable than most dyes, which makes them the perfect choice for an embossing ink. Water-based pigment inks do not dry on coated paper or nonporous surfaces.

LIQUID INK AND INK PADS

Tim Holtz's Distress Ink Pads, combined with specially-made nibs and sponges, will color images in an easy and controlled manner. The vivacious colors can be layered, blended, or toned down by using a foam pad. Distress inks work on most types of black-and-white photos printed on photo paper, inkjet, laser, or toner copies, but I especially love the effects they produce on glossy photo paper.

CACHE — Smeared with alcohol inks and water

LODGING — Crumpled and swiped with ink pads

LOVE NEST — Alcohol inks and water, brayer and foam pad

ROOST — Painted with Distress Ink Pads and nibs

FIVE LIVES — Inks smeared with ink pad, crackle gel accent

ROUGHING IT

3

TEXTURE

The creative act lasts but a brief moment, a lightning instant of give-and-take, just long enough for you to level the camera and to trap the fleeting prey in your little box.

—HENRI CARTIER-BRESSON

Texture has the potential to take your art places you never thought it might tread. Surround and embed your images with dimension and build up parts of your artwork while complementing your focal point. Watch your images undergo a metamorphosis.

DREAMCATCHER — *Black-and-white photograph hand-painted with oils, molding paste, acrylic paint, string*

DEPTH AND DIMENSION

Alter images by painting over them, peeling parts away, or by adding a variety of products that are available to create depth in your art.

Project Launch

Begin by using lab-processed or photocopied images as core building blocks for your art pieces. Use a wrapped canvas, canvas panel, heavy paper, or wood box with enough surface area to provide some additional working room around the images once they are attached. Apply one or two coats of gesso as a base. Once the gesso is dry, wash the substrate with any color.

Don't glue down your image yet, but decide where you want it to go so you can start to build up the area around it. On the following pages, you will be introduced to the many materials that will build texture and character into your artwork.

CRACKED — Black-and-white photograph hand-painted with oils, crackle paste, molding paste, acrylic paint

NOTCH TOOL

Gesso and a notch tool are a few of my favorite things. Notch tools, or texture blades, are used to apply the mud or glue to a surface before tile is adhered. The craters it makes allow the glue to bond with the tile and the surface. They are inexpensive and can be found at hardware stores. You can use a notch tool to create wonderful patterns over, under, and on top of your images.

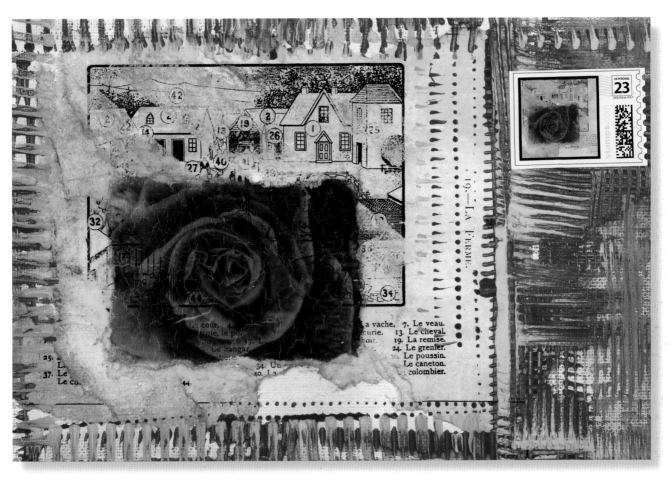

TAINTED ROSE — Black-and-white photograph hand-painted with oils, acrylic paint, notch tool, postage stamp, ephemera

Project Launch

The square edge or pointed edge of the tool can create a plethora of unique designs. Put some acrylic paint or gesso onto a canvas with a palette knife. Begin creating texture by pulling the tool through the paint, spreading it across the canvas. You can construct ridges, crisscross effects, or use the tool to make a series of dots or squiggles. Add additional color to your artwork and pull the comb back and forth through the colors.

◄ Notch tool samples

No great artist ever sees things as they really are. If he did,
he would cease to be an artist.

—OSCAR WILDE

CRACKLE AND MOLD

I am drawn to old doors, decaying walls, and the history of ancient objects displayed in the character of their appearance. Create your own character with crackle paste, an instant and unique method for adding dimension.

CRACKLE PASTE

Not only is it fun to use, but the texture and randomness of crackle paste can also add powerful drama to your art. The deep cracks add intense, often grungy, depth and interest. Use it as an accent or build your piece around its attributes.

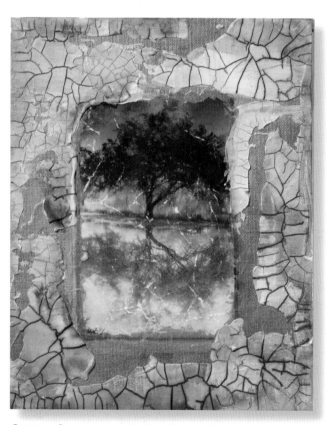

POETIC GUARDIAN — Black-and-white photograph, hand painted with oils, crackle paste, acrylic paint

Project Launch

With a palette or spackle knife, apply crackle paste to the surface of your substrate. Allow the base color to show through in places. (In the sample above, I applied crackle paste over one coat of gold gesso.) The thickness of an application of crackle paste affects the size of the crackle fissures. Very thin coats may not show any cracks at all. Thick coats of up to 1" (2.5 cm) may only crack on the top and not entirely through the paste. Mess around! Experiment with varying amounts of crackle paste until you attain a look that appeals to you.

Create additional textural effects by taping a stencil to the surface of an art piece. Use a palette knife to apply crackle paste through the stencil. Remove the stencil and allow it to dry completely. Sand and color with ink pads. ➤

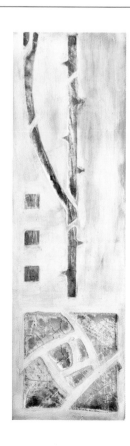

MOLDING PASTE

With molding paste we become the sculptors of our own dimensional components, limited only by our imaginations.

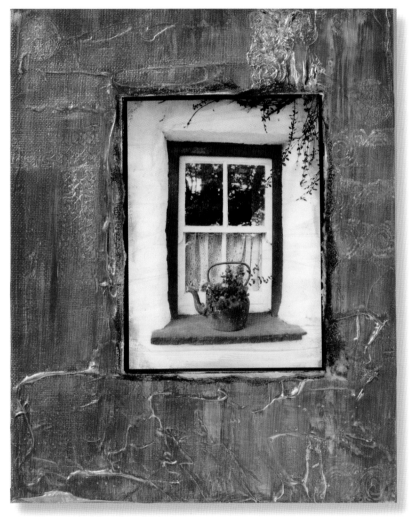

POT LUCK — Black-and-white photograph hand-painted with oils, molding paste, acrylic paint

Molding paste is made by several companies and is available in different weights. It's a terrific way to embed photographs into your art so they no longer appear to be sitting on top of your background, but instead form a cohesive combination. Embed your image into the wet paste and let it ooze up, obscuring the edges. If you let molding paste dry it will achieve a claylike consistency. The paste can be mixed 50/50 with gel medium or heavy gel medium to keep it flexible and allow greater modeling ability. Apply with a knife, brush, or decorating tools. Experiment with different implements and palette knives to create singular ridges and remarkable dimensional effects.

Project Launch

To create a baroque form or bas-relief look, apply an even layer of molding paste to your work. While it's still tacky, stamp into it with rubber stamps. If the molding paste is more wet than tacky, the stamp will create a pattern instead of the actual stamp image. This type of unstructured element can actually breathe life into a static composition. After stamping into molding paste, stamp again with the remaining paste still on the stamp to create a delicate impression that echoes the first.

TIPS

• Wash hands and tools in soap and water. Keep tools wet while working to prevent permanent adhesion of the acrylic materials. Wash completely when finished.

• Try using stamp pads on the tips of molding paste once it is dry to accent and deepen the color.

Light Molding Paste sample

Molding Paste sample

GEL MEDIUMS

Gel mediums are perfect for mimicking oil-like brush and knife work. They peak well and easily accomplish impasto techniques. The wide variety of gel mediums on the market all mix well with acrylic colors and increase their transparency and brightness while respecting the characteristics of the paint. They are available in matte or gloss finishes. The matte gel will soften your images while a glossy finish will perk up the colors and give your photograph a glossy finish.

Gel mediums act as a strong glue and work well to attach found objects and collage elements to your art. Use gel medium as a binder for powdered pigments, sand, and other textural elements.

In Mementos, several layers of gloss medium were added to create a thick glaze in which the images were embedded. It is imperative each layer dries completely before applying the next to avoid the appearance of a milky coating. Glass bead gel mimics water on the edges of the resin sand texture. ▼

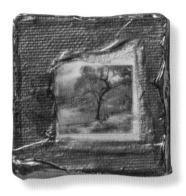

Soft gel

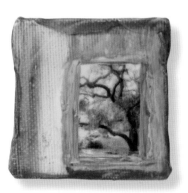

Heavy matte gel

Gloss gel medium

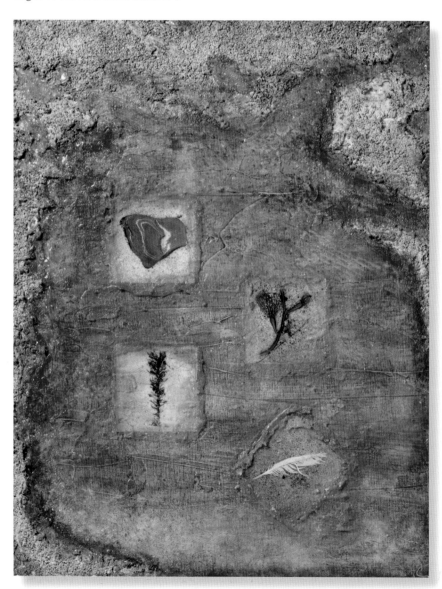

MEMENTOS — Black-and-white sepia-toned photographs, heavy pumice paste, acrylic paint, resin sand texture, glass beads texture, gloss gel medium

NOTEWORTHY

- Gel mediums do not yellow and add a layer of protection from dirt or scratches to your art.

GELS AND PASTES

There are a wide variety of different gels and pastes available that will create different textures and interesting effects. They all mix well with acrylic colors or can be used in their natural state.

Top row: Stucco Paste, Black Lava, String Gel
Middle row: Blended Fibers, Garnet Gel, Glass Bead Gel
Bottom row: Course Pumice Gel, White Opaque Flakes, Resin Sand Texture

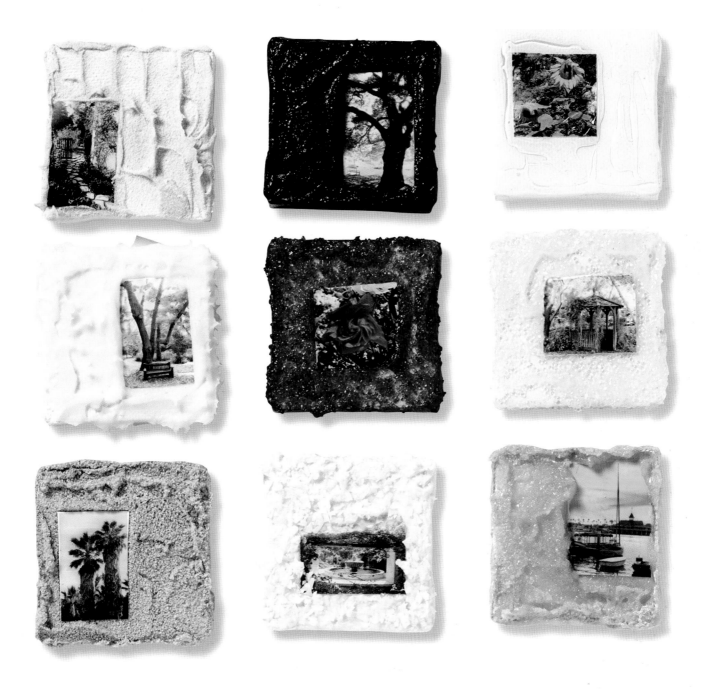

SCRATCH, PULL, AND TEAR

Be adventurous: tear your photographs into strips and rearrange them on your substrate. I find art that is imperfect to be perfectly fascinating for this technique. Drastically alter the image by scratching, pulling, or tearing, and use the created imperfections to assist your artistic storytelling.

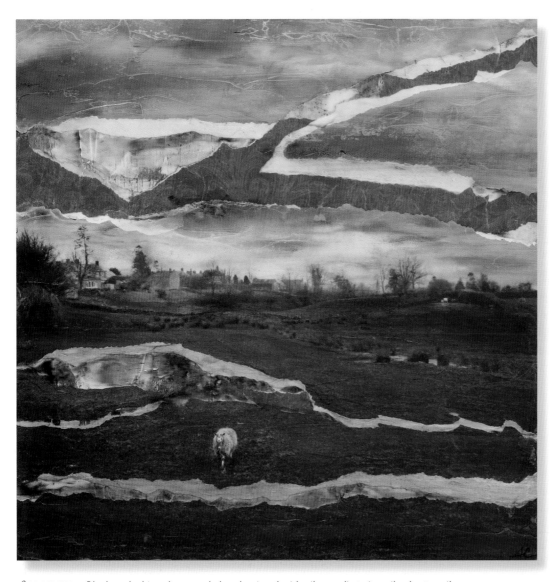

SOLITUDE — Black-and-white photograph, hand-painted with oils, acrylic paint, oil color pencils, handmade paper, walnut ink

TIP

• Dental implements make great tools to scratch away the surface. New bits can always be added over what you have lifted to create more layers. You can use matte medium or glaze with a wash of color between each layer.

SAND

Sandpaper is an excellent tool to distress and lift away parts of your art. I reach for mine whenever I want a photograph to feel more attached to its base. Sandpaper smoothes edges, clears away color, and adds scratches that a wash of paint can fill, thus adding both depth and texture.

HAT — Sanded black-and-white photograph, walnut ink wash, markers, rub-on

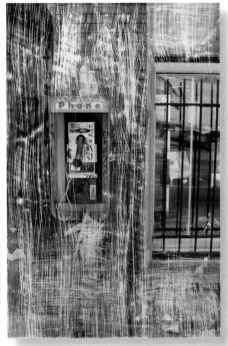

HANG UP — Sanded color photograph, markers, walnut ink wash

TIPS

• Use different grades of sandpaper for different effects.

• Try scratching your photograph in different directions.

• Place your photograph on a rough surface and then lightly rub sandpaper over the top.

• Color your sandpapered images with markers, color washes, acrylic or oil paint, and water-soluble crayons to achieve different looks.

• Use sandpaper over an entire photograph, then cut and tear and use in your collages.

• Experiment with sanding on photographs processed in a lab versus photographs you run on your computer. The emulsions are different and will present different effects. When using lab-processed photographs, dip them in water first to loosen the emulsion before using your sandpaper.

TIMELINE

The first recorded instance of a sandpaper-like material is in China, where crushed shells, seeds, and sand are glued with natural gum to parchment.

13th century

Coated abrasive paper is sold on the streets of Paris.

1769

A United States patent is issued for a machine that produces coated abrasives.

1835

Artist Joan Miro paints on sandpaper.

1934

1600

Sharkskin is used as sandpaper by Native Americans on the California coast.

1833

Sandpaper, known as glass paper because it contains particles of glass, is manufactured by John Oakey's company in London.

1921

3M introduces waterproof sandpaper, known as Wetordry, for use in automotive paint refinishing.

CRUMPLE

Crumple, rumple, and wrinkle your photographs and then add color. You can iron photographic paper on the reverse side to flatten it enough to adhere to your substrate. The accumulated pastel and oil stick color will remain in the wrinkles and ridges.

Project Launch

For this piece I used a 20" x 24" (50.8 x 61 cm) black-and-white photograph that I handpainted with oils. Cut your photograph into several uneven sections, tearing edges off in places. Wet the photograph paper and crumple the pieces in your hand, then uncrumple and rub them with oil pastels. The pastels will settle in the cracks and emphasize the color. Smudge further with your finger or a sponge. Prepare a wood "canvas" with gesso, adding molding paste and acrylic paint. Attach the photograph with gel medium and fill the cracks between the photo pieces with embossing powder, using a heat gun to melt and set. Add more oil pastels and run an alcohol dye ink pad over the peaks of the molding paste for accent.

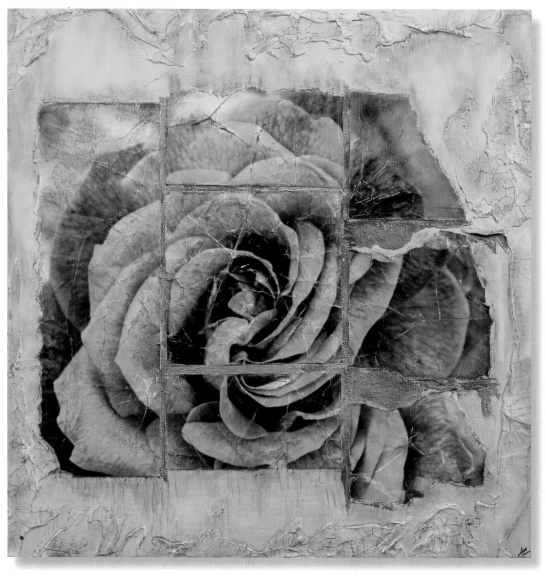

LONGING — *Black-and-white photograph, hand-painted with oils, acrylic paint, molding paste, crackle paste, oil pastels, embossing powder, inks*

MANIPULATE YOUR PHOTOGRAPHS

Décollage is the opposite of collage; instead of an image being built up from existing images, it is created by cutting, tearing away, or otherwise removing pieces of an original image.

Project Launch

To create what I call a "biddy" look, apply artist paper to your substrate and add gel medium over the top. Attach pieces of papers of text or other papers and let it dry to the point of being tacky. Lift the papers you have glued down, letting some of the pieces tear away. Sand and manipulate the photograph so it feels embedded among the scraps. It is a disorderly look, but one that adds interest and distress to your art.

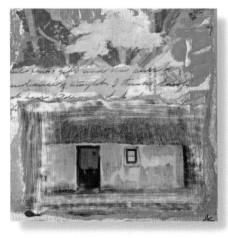

THE YELLOW COTTAGE — *Black-and-white photograph, hand-painted with oils, artist papers, text paper, acrylic paint*

ALTERED ARTICULATION

Expand your design lexicon while getting your creative juices flowing by putting your own twist on some of these ways to manipulate your photographs and artwork.

Decalcomania *is a process of spreading thick paint upon a canvas, then — while it is still wet — covering it with further material such as paper or aluminium foil. This covering is then removed (again before the paint dries), and the resultant paint pattern becomes the basis of the finished painting. The technique was much employed by artists such as Max Ernst.*

Entoptic graphomania *is a surrealist and automatic method of drawing in which dots are made at the sites of impurities in a blank sheet of paper, and lines are then made between the dots.*

Étrécissements *is considered a reductive method, whereas collage is perceived as an additive method. The results are achieved by cutting away parts of images to create a new image.*

Exquisite corpse *(also known as "exquisite cadaver" or "rotating corpse") is a method by which a collection of words or images are assembled collectively. Each collaborator adds to a composition in sequence, either by following a rule or by being allowed to see the end of what the previous person contributed.*

Frottage *is a method in which one takes a pencil or other drawing tool and makes a "rubbing" over a textured surface. The drawing can either be left as is or used as the basis for further refinement.*

Fumage *is a technique in which impressions are made by the smoke of a candle or kerosene lamp on a piece of paper or canvas.*

Grattage *is a surrealist technique in which dry paint is scraped off.*

Heatage *is created by taking an exposed but unfixed photographic negative and heating it from below, causing the emulsion and the image to distort when it is developed.*

Latent news *is taking an article from a newspaper and cutting out individual words or phrases and then reassembling them.*

Movement of liquid down a vertical surface *is achieved by dripping some form of liquid down a vertical surface to create a textured background or layer.*

Outagraphy *is a photograph in which the subject of the photograph is cut out and placed on a new surface.*

Parsemage *is taking the dust from charcoal or colored chalk and scattering it on the surface of water and then skimming it off by passing a stiff paper or cardboard just under the water's surface.*

Soufflage *is a technique in which liquid paint is blown onto a surface to inspire or cover an image.*

Triptography *is an automatic photographic technique whereby a roll of film is used three times (either by the same photographer or, in the spirit of exquisite corpse, three different photographers), causing it to be triple-exposed in such a way that the chances of any single photograph having a clear and definite subject is nearly impossible. Finding any edges on the negative itself during the developing process is a nearly impossible task. Typically the developing of such a roll of film is an exercise in automatic technique, cutting the film by counting sprocket holes alone, with no regard for the images present on the negative.*

DRIP

There is an ethereal and ancient appeal to imagery painted or drizzled with wax. Add beeswax to your own art and you will transport it to an otherworldly dimension.

BEESWAX AND ENCAUSTIC

Encaustic, also known as hot wax paint, is a paint consisting of pigments mixed with beeswax and fixed with heat after its application. It is a very spontaneous and versatile medium. It can be modeled, layered, sculpted, textured, and combined with collage materials. It dries almost immediately and can be reheated with heat lamps or heat tools to manipulate the wax and extend the amount of time you have to work with the material.

TIP

• Votive candles work perfectly when small amounts of wax for coloring or drip effects are required.

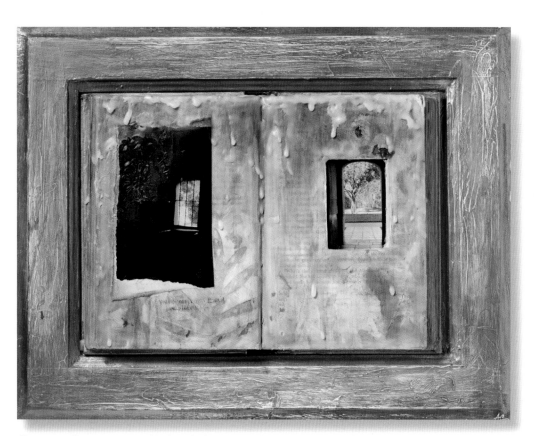

BOOK OF DEPARTURE — *Black-and-white images hand-painted with oils, acrylic paint, beeswax, found book, wood door panel*

Project Launch

Beeswax can be purchased in blocks. It melts to a clear substance but does appear cloudy when applied over images. Chip off a piece of the block to heat in a temperature-regulated craft or wax-heating pan. Use a brush or sponge brush to apply the wax over an image. The more coats used to cover a surface, the more distant and obscure the image will appear. Use a heat gun to reheat the wax and move it away from the image if you want less coverage. The same process is used to apply a pigmented wax, or encaustic. Drips of wax can be applied with a spoon as shown in this sample, or by turning a beeswax candle sideways and dripping the wax onto the art.

NOTEWORTHY

• A coating of beeswax over a photograph will provide protection, but avoid displaying in direct sunlight or by a heater.

Wax Impressions

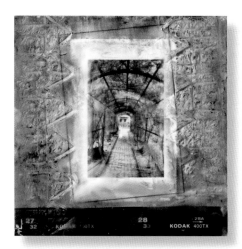

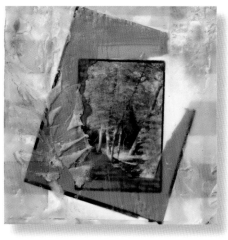

Beeswax can also be used for creating impressions. Here, hand-painted images are glued with matte medium to wood panels. Large frames of unexposed film are attached over the photographs. Immediately after that step, the surface is coated with hot beeswax, which is stamped into with rubber stamps to create a rich, embossed feel.

FLOW — Black-and-white image hand-painted with oils, acrylic paint, stamped-into beeswax, negative

ROOTS — Black-and-white image hand-painted with oils, acrylic paint, stamped-into beeswax, negative

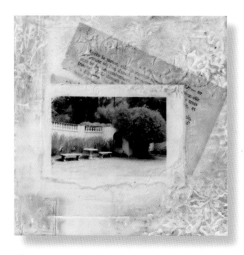

◄ *REMNANTS* — Black-and-white image, transparency, beeswax, objects, buttons, talismans, coins, material, corrugated cardboard, paper

SILENCE — Black-and-white hand-painted with oils, acrylic paint, stamped-into beeswax, vintage book sheet, negative

TIMELINE

Beeswax is used in cave paintings in Lascaux caves in southern France. Egyptians use beeswax for ship-building. Romans use beeswax as a protective agent on painted walls.

15,000 to 13,000 B.C.

The Egyptians use beeswax to make wicked candles.

3000 B.C.

Romans use beeswax in broth, as a skin soft-ener, and have statues made of themselves in beeswax.

A.D. 23 to 79

Beeswax is considered valuable enough to become a form of currency.

401 to 500

Beeswax is used in early cake mascara and other cosmetics.

1915

6000 B.C.

Beeswax is used to coat cheese, to protect it as it ages.

400 B.C.

The Greeks use beeswax as a filler in repoussé.

100 to 300

Fayum mummy portraits are made from encaustic wax on wood panels.

1706

Louis XIV of France in-troduces envelopes sold with instructions on how to seal them with wax.

EMBOSS

My experimentation with melting embossing powders led my art into undiscovered territory. I have become hopelessly addicted to their luminous qualities.

EMBOSSING POWDERS

Create a raised surface by melting embossing powder resins. With hundreds of colors and clear, shiny, metallic, puffy, and textured finishes to choose from, embossing powders can really expand your artistic toolbox. The process is simple: apply an embossing ink to a stamp, stamp an image, then sprinkle embossing powder over the stamped area. Heat the powders with a heat tool until you observe a change in the texture, then let it cool completely. Repeat with additional colors if you like!

Embossing powders can also be spilled over only the edges of an image. Apply a glue stick to the areas you wish to emboss and sprinkle the embossing powder over the glue. Press the powder down with a piece of paper or card. Remove the excess powder by tipping it onto a craft sheet or piece of card stock and pouring it back into the container. Then apply your heat gun to the powdered areas until it melts.

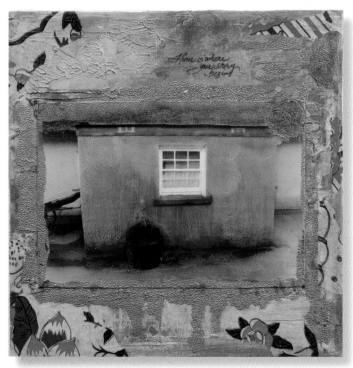

YEARN — *Black-and-white photograph hand-painted with oils, acrylic paint, paper, rubber stamps, embossing powder*

For a thick embossed image, create a puddle of embossing powder by applying a layer of glue stick over an already set layer of embossing powder. Let it dry between applications and repeat the process. Once you have a thick buildup, heat it until it bubbles and stamp into it immediately, leaving the stamp on the surface until it cools to create a negative version of the image.

A texture of embossing powder unifies the background in this portrait of 1" (2.5 cm) photographs, known as "inchies," mounted on paint chip samples. ▼

MOSAIC SCENERY — *Photocopied photographs hand-painted with oils, paint chips, embossing powder*

Fabric Fusion

Fibers can be fused together with the help of embossing powders and an iron or heat gun to make a colorful background.

Project Launch

To fuse fibers together, create a pile of threads on card stock. Sprinkle them with embossing powder and place a nonstick craft sheet over the top. Apply heat with a hot iron to both sides. You can also use a heat gun to heat the embossing powders so they melt over the fibers, fusing them together. In the process you may singe some of the fibers, but that too can look interesting.

◄ *GLEE CLUB* — *Black-and-white photograph hand-painted in oil, fibers, clear embossing powder*

NOTEWORTHY

• I use the 15" x 18" (38.1 x 45.7 cm) nonstick craft sheet made by Ranger. This slick, nonporous, reusable, protective sheet that nothing sticks to also withstands high temperatures that even hot glue won't penetrate or distort. Any excess melted product, once cooled, can be easily removed and placed back into the melting pot or stored for future projects. Paint and other products are easily wiped off. The sheet is perfect for collecting excess embossing powder that can be funneled back into its container.

> Art doesn't want to be familiar. It wants to astonish us. Or,
> in some cases, to enrage us. It wants to move us. To touch us.
> Not accommodate us, make us comfortable.
>
> —JAMAKE HIGHWATER

EMBED

Vellum can literally transform a photograph into a mysterious and ethereal image by embedding your art underneath it. Vellum adds warmth and draws the eye into a piece to look further for hidden nuances.

VELLUMS

Originally, vellum and parchment papers were white, translucent writing surfaces made from stretched animal skins, usually calf, goat, or sheepskin. Modern vellum, called vellum paper or imitation vellum, is made out of wood pulp or cotton fiber. Vellum comes in various translucent shades, and is sometimes enhanced with a faint grain, hair markings, or printed designs. Paper vellum is used in applications where tracing is required, such as for architectural plans, and is popular among artists and paper crafters.

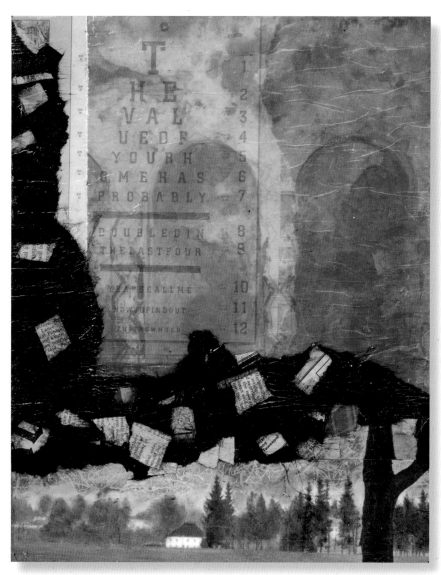

SECRETS — Black-and-white photograph hand-painted with oil stamped into, vellum with photo image, handmade papers, ephemera

ADHERING VELLUMS AND TRANSPARENCIES

Use a glue stick around the edges.

Sew it down with buttons.

Use colored brads or staples.

Use gel medium or matte medium, Diamond Glaze, or a clear adhesive. To prevent a puddle of liquid showing through on a transparency, smear it with your finger before pressing it down.

Use double-sided tape, then cover it up with either decorative tape or strips of cut or torn paper or ribbon to create a decorative frame.

A Xyron machine works well if you want adhesive to cover the entire piece of vellum. A brayer or the long side of a bone folder will ensure a crease-free adhesion.

Project Launch

Cut a template out of cardboard and paint it with acrylic paint. Choose and attach two primary images. (Here, the hand-painted photograph of an angel statue was added to the right-hand corner. The shadow self-portrait was cut into an arched shape and used as the central motif.) Use an embossing ink pad to stamp around the center, add embossing powder, and heat-set. Add blotches of walnut ink. Cut vellum into a house shape and attach it. Stamp the vellum with a piece of corrugated cardboard washed with gesso to create a random-lined design. Run an ink pad over the sides of the piece so it blends the papers together and there are no white edges. Notice how the vellum creates a mood far different from the original piece in the samples here.

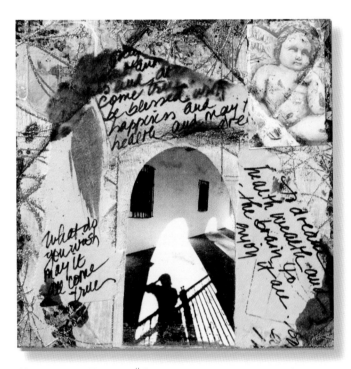

WISHES AND DREAMS #1 — *Black-and-white photograph, transparent oil paint, rubber stamp, walnut ink, acrylic paint, black pen*

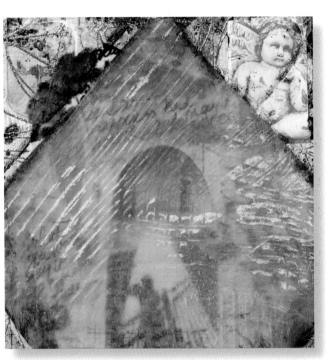

WISHES AND DREAMS #2 — *Black-and-white photograph, clear vellum paper, gesso, corrugated cardboard*

TIMELINE

Gandharan Buddhist texts are written on vellum.

1st century

Vellum is used widely for paintings if they need to be sent long distances.

Pre-14th century

Old-master prints are sometimes printed on vellum, especially for presentation copies, until the seventeenth century.

Pre-17th century

13th and 14th centuries

Vellum is made from the skins of stillborn or unborn animals.

1455

A quarter of Johnannes Gutenberg's first Bible is printed with movable type on vellum.

21st century

British Acts of Parliament are still printed onto real vellum for archival purposes.

No place is boring, if you've had a good night's sleep and have a pocket full of unexposed film.

—ROBERT ADAMS

TRANSPARENCIES

The possibilities for using transparencies in your art are endless. They can be printed on your computer printer, painted, stamped, written on, cut up, and used in a variety of ways. They can create windows to highlight messages or art beneath them, and add a sleek and exciting layer to your altered creations.

Commercial transparencies can be purchased, usually by the sheet, and contain photographic images or designs. These transparencies are usually (but not always) protected by a coating on both sides and can be used in or over your art.

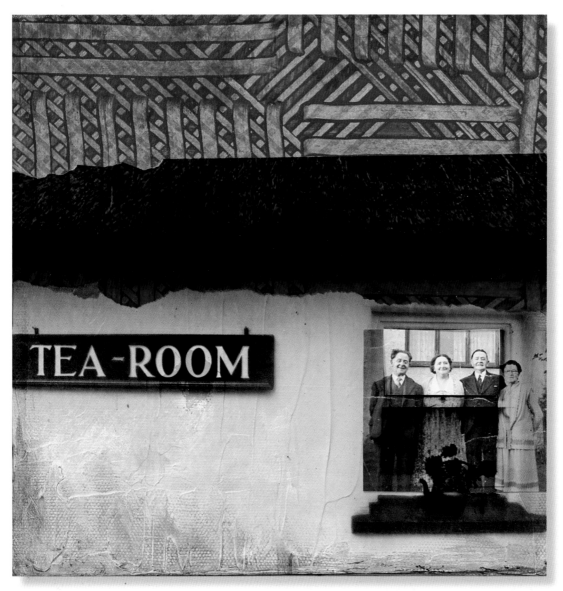

CUPPA TEA — Vintage photograph, transparency, acrylic paint, handmade paste paper

Project Launch

To make a reliquary, paint the back side of a canvas. Any size will do. The deeper the sides of the frame, the deeper your box will be. Place a transparency between a heavyweight plastic sheet to create a door. Glue plastic to fabric to create a hinge, and add a button with ribbon for a closure. Now you can place hidden treasures inside.

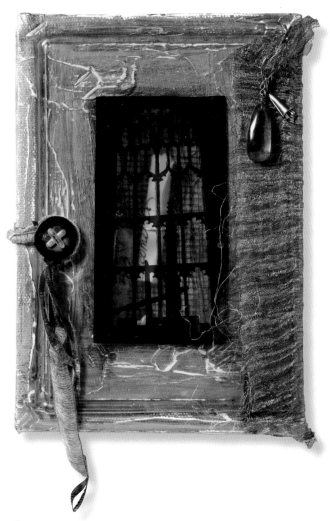

RELIQUARY — Canvas frame, transparency, acrylic paint, molding paste, antique button, ribbon, ephemera

DESERT OPUS — Transparency, gesso, notched paper, sheet music

Project Launch

You can also make your own transparencies by purchasing transparency film at office supply stores or online. They are available in 8 1/2" x 11" (21.6 x 27.9 cm) sheets, so you will probably want to fill up the page with images before you print them on your printer. Transparencies you make yourself will have a slick side and a rough side. The rough side is the one you will print on.

If you choose to paint the slick side of your transparency with acrylic paint or markers, let each layer dry completely before applying the next layer of paint to intensify the colors.

Painting on the rough side of a transparency can be tricky. Applying paint can remove the ink on the side you printed. Here, I let my brush lift off some of the ink to create a more decrepit look. ➤

FRUIT FOR THOUGHT — Black-and-white image, transparency hand-painted with acrylic paint

MIX IT UP

Look beyond your craft store for artful materials. Hardware stores contain exciting possibilities. I was delighted to discover that household paint delivers fantastic results when combined with textures like stucco.

INTERIOR PAINTS

The market of household paints and interior paint design has grown by leaps and bounds in the past couple of years. Treat yourself to a visit to your local hardware store. You will find designer-style products that create the look of suede, leather, and river rock. There are also metallic, pearlescent, and glaze finishes. While paint treatments are meant to be applied to your walls, altered artists will find many of these products work in their art. You can purchase sample sizes of paint colors for a fraction of the price of artist pigments. Some colors are more transparent than others. The colors are rich, deep, and varied.

Using a woolly paint roller, a sea sponge, or a wood grain texture tool are just a few ways to create textures. Some colors are quite transparent with one coat. Two coats provide luxurious coverage.

Sponge and notch tool sample

Stamping onto interior paint

Stamping into interior paint

Stamping into or onto household paint also presents interesting results. Large foam stamps work well, but finer stamps with more detail can also be tried. To stamp onto your substrate, don't dip your stamp in the paint, but apply it quickly with a brush, making sure you don't let the paint settle in the crevices and block up the details. You do need to work swiftly because latex paint dries very quickly. To stamp into house paint, brush your paper with one coat of paint and stamp immediately, twisting the stamp slightly to make sure you get a good impression. If you give your paper more than one coat, the undercoat is what will show through. If you leave your stamp on the paint while it dries, it will tear away some of the underneath layers when you remove it, creating a "biddy" look.

STUCCO PATCH

Premixed stucco patch is another texture item available at the hardware store. Heavier and thicker to apply than a molding paste or texture gel, it adds heft and weight to your art piece, which makes it less suitable for journal pages unless only a small amount is used. This medium provides a gritty result that can be stamped into, molded, manipulated, and painted in various ways.

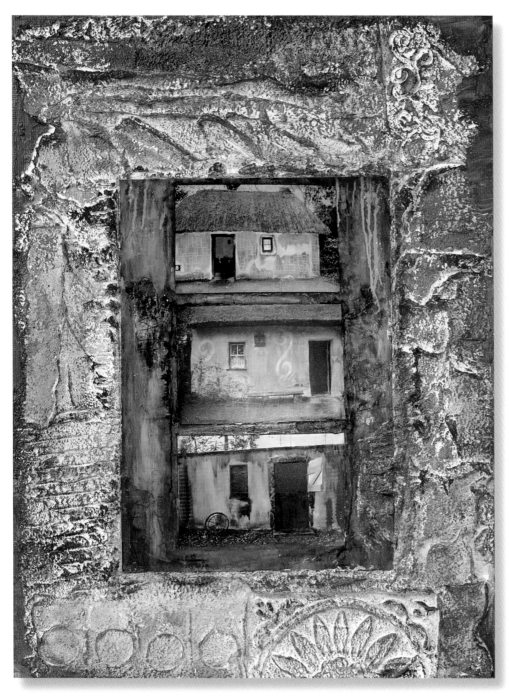

IF THESE WALLS COULD TALK — *Black-and-white photographs hand-painted with oils and printed on glossy paper, premixed stucco patch, house paint, foam rubber stamps, crackle paste, molding paste*

EFFECTS AND BEYOND

The moment you cheat for the sake of beauty, you know you're an artist.

—DAVID HOCKNEY

DISCOVER

Think of yourself as an explorer. Art is all about discovery. Find new ways to add texture to your creations. Try adding some of the materials on the following pages just for fun. As you walk down the path of exploration, you may just discover some new techniques and elements that excite you.

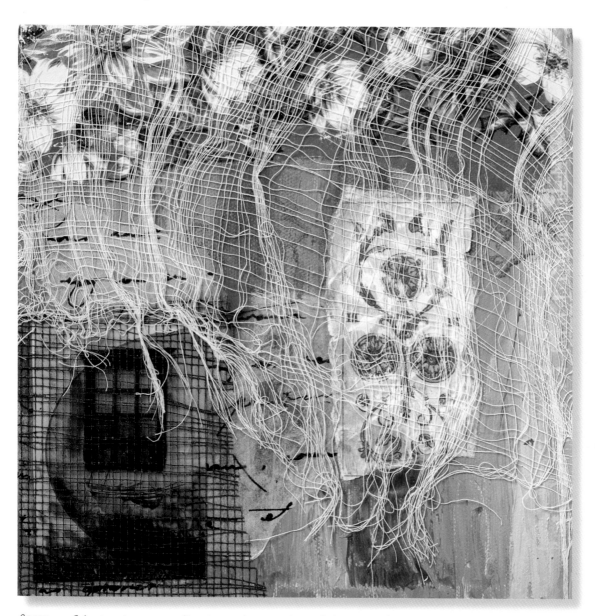

ORIEL — *Color transparency, acrylic paint, mesh, paper, cheesecloth, tissue, ephemera*

STAMP

Rubber stamps, whether handmade or store-bought, can provide a core motif that makes a piece cohesive. Interestingly, I rarely use an entire rubber stamp; using a select portion of it is sometimes all that's required.

HAND-CARVED STAMPS

Project Launch

Decide on an image and draw it directly onto an eraser or a carving medium, using a ballpoint pen, permanent marker, or soft pencil. You may have an image you love on your computer. Many software programs have a "Stamp" selection that will translate a picture into a bold image, which is then easy to carve. Use a photocopier to enlarge or reduce. Here are two ways to transfer your image to the eraser or carving block.

To make a **pencil transfer**, begin by drawing or tracing over your chosen image using a pencil, then turn the paper facedown on the carving material and rub the back of the paper to transfer the graphite image to the carving material.

A **tracing paper** transfer can be made by placing the image on top of a sheet of tracing paper, which is on top of a carving block, and using a pen or stylus to draw around the image. This will transfer the graphite or wax from the tracing paper to the block. When using this method your image must be reversed, especially if you are tracing numbers or letters.

When carving a print block, always carve away from yourself with slow and even strokes. Try carving the most difficult part of the image first. Make shallow cuts and deepen the grooves if you need to. It's a good idea to test your stamp as you go along to see what lines need to be removed. Some carvers prefer to leave some of the small lines, which give the stamp a woodcut or primitive look. Others prefer to remove all the lines to present a clean carved stamp. Experiment with the two looks to find your personal preference.

You can tap your stamp with an ink pad to print. Alternatively, use a brayer to spread paint or ink on a glass or plastic plate, then dip the stamp onto the surface to pick up the color. Always clean and dry the brayer completely after each use. Dried paint on a brayer will create pits and bumps and then it will not spread your ink cleanly.

Use lukewarm water and mild soap to clean water-based ink from stamps, or use baby wipes. Do not rub the surface of the stamp and do not use hot water or excess rubbing and heat, which will cause the material to crumble. Allow your stamp to air-dry. Oil-based block printing ink can be cleaned up with vegetable oil and a paper towel. If it dries on the glass, use a razor blade to scrape off any dried ink, then clean the glass with vegetable oil.

There are local businesses and national companies that will take your images and turn them into stamps. Alternatively, carve your art into erasers and other soft materials intended for carving, or harder linoleum blocks to create stampable designs. I carved these designs freehand and used acrylic paint to print the primitive designs shown here. This is a perfect way to embellish your art with original and unique images.

BIRD IN THE HAND — Hand-carved rubber stamp on carving block

Imprint on paper of hand-carved stamp

RED BIRD FOR SARAH — Hand-carved stamp art, acrylic paint

EMBOSSED STAMPING

Use embossing powders with your stamps to add texture and glitz. The embossed textures over a photographic surface can make an image feel more integrated, or "embedded," into a final work of altered art.

Project Launch

Stamp an image with an embossing stamp pad. Sprinkle embossing powder onto the image, shake the excess onto a piece of paper or card stock, bend it in half, and pour the excess powder back into the container. Tap off the excess powder or use a soft brush to carefully remove any stray powder from your art. Don't forget to cap your embossing powder before starting up your heat gun.

If you want the image to emboss perfectly, use a cotton swab or small brush or toothpick for cleanup. Use the cotton swab to apply extra embossing pad ink if you need to fill out any areas with more powder.

Heat the powder with a heat tool, keeping it in constant movement while holding it about 1" (2.5 cm) away from the art surface. With practice, you will get the knack for how long it takes the powder to melt into resin and rise for a textured feel.

For more ways to use embossing powder, see the Mosaic section on page 102.

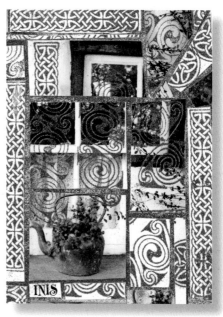

KETTLES ON — Black-and-white photograph with transparent oil paint, printed on glossy paper, rubber stamps, embossing pad, embossing powder

SILVER CHAIRS — Rubber stamp, embossing powder, embossing pen

TIPS

• A paper plate makes a good funnel when you want to empty powders back into the container.

• Beware of the heat generated from a heat gun. It can burn. Use the end of a paintbrush or other tool to get the corners of your photos embedded into the melting powder. Never use your fingers.

TIMELINE

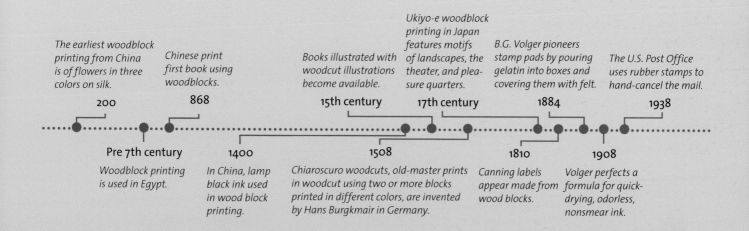

The earliest woodblock printing from China is of flowers in three colors on silk.
200

Chinese print first book using woodblocks.
868

Books illustrated with woodcut illustrations become available.
15th century

Ukiyo-e woodblock printing in Japan features motifs of landscapes, the theater, and pleasure quarters.
17th century

B.G. Volger pioneers stamp pads by pouring gelatin into boxes and covering them with felt.
1884

The U.S. Post Office uses rubber stamps to hand-cancel the mail.
1938

Pre 7th century
Woodblock printing is used in Egypt.

1400
In China, lamp black ink used in wood block printing.

1508
Chiaroscuro woodcuts, old-master prints in woodcut using two or more blocks printed in different colors, are invented by Hans Burgkmair in Germany.

1810
Canning labels appear made from wood blocks.

1908
Volger perfects a formula for quick-drying, odorless, nonsmear ink.

STAMP AND INK PADS

Today, artists may choose from a wide variety of ink pads for all different applications.

Felt stamp pads are commonly found in office supply stores. They consist of a thick felt base covered with fabric. Colors are limited.

Dye-based pads are a current invention. The ink dries quickly, is acid-free, and is available in a wide range of colors.

Dye-based ink pad over sanded image

WINTER WONDERLAND — *Black-and-white photograph painted with dye-based ink pads*

Pigment stamp pads are made with coloring agents that are stable and nonreactive with other materials.

Chalk ink pads have chalk added to them for a matte finish.

Chalk pad on collaged image

ORNAMENTAL — *Black-and-white photograph painted with chalk ink pads*

Iridescent ink pads have iridescence added to them to bring shine to your art.

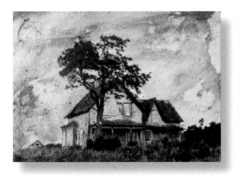

Distress ink pads are made with acid-free, nontoxic, fade-resistant, water-based dye inks. They are perfect for vintage, stained, or aged effects.

Distress pad over clear gesso

TOTO TOO — *Black-and-white photograph painted with dye-based ink pads*

Embossing ink pads create a raised, shiny, metallic, or textured impression when used with embossing powders and a heat source. They are slightly tinted so you can see exactly what you've stamped.

Scented ink pads are made with acid-free, nontoxic dye ink, each with its own distinctive scent.

Washable ink pads are designed for children for easy cleanup.

Specialty ink pads make it possible to stamp on just about any surface, including fabric, wood, leather, glass, chinaware, plastic, metal, and skin.

TIPS

• Run a stamp pad along the edge of your art to blend and disguise any white edges.

• Clean your stamps after using them with a baby wipe or a commercial stamp cleaner.

• Never immerse a rubber stamp in water unless you want to remove the stamp image from the base.

• Use a toothbrush to clean the edges of your stamps if using gesso or molding pastes.

• Re-inkers not only bring new life to your stamp pad, but the ink can also be used in your art straight from the bottle.

MILK STAMPING

Stamping with milk creates an appealing, warm brown, crème brûlée sort of look once heated with a heat tool. It reminds me of the crusty top of the custard pie my mom baked when I was a child.

Project Launch

Use condensed milk because it clings to the stamp, particularly after it has been sitting out for a while. Other milks are too thin unless a glaze is added. Use larger foam stamps, with less detail. The milk fills the crevices on finely detailed stamps, and therefore, details are lost.

Dip your foam stamp into a plate filled with condensed milk or brush milk gently over the stamp. Place the stamp directly on the paper and let it sit for several minutes.

Use a heat tool to develop the color by heating the milk on your substrate to a boil. The more you heat it, the darker the stamped image becomes. There is no odor after the milk stamping dries, but while heating it you will swear there is a pie in the oven!

BLEACH STAMPING

To use bleach stamping in your art, coat your substrate with black gesso, and let it dry. Spread a layer of Soft Scrub bleach cleanser over parts of your substrate, using your palette knife to scratch away any areas you wish.

Use a photocopier to print one or two photographs on matte photograph paper, or use photography lab prints. With a palette knife, apply Soft Scrub bleach cleanser to parts of the photographs, and then stamp into them with large-format foam stamps. Clean your foam stamp immediately and let the photographs dry for a couple of hours. Use your palette knife to scrape off excess bleach, which has now dried. The design will burn itself into the photograph. Add a protective coating of gloss or matte medium to seal.

Milk stamping sample 1

Milk stamping sample 2

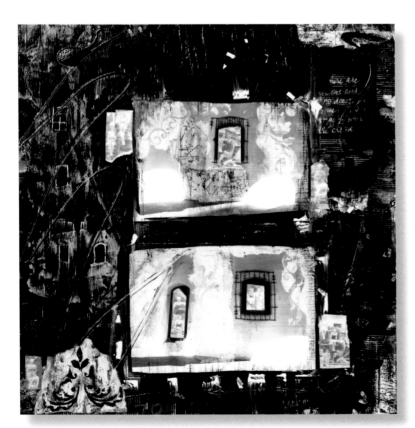

THE DARK SIDE — *Black-and-white photographs on matte photo paper, vintage photographs, bleach, String Gel, acrylic paint, white pen, black glaze pen, chalk ink, white stamp pad, rubber and foam stamps, wallpaper*

NOTEWORTHY

• Soft Scrub does not have the toxic fumes that regular bleach has; however, you should still work with it in a well-ventilated area. As with all bleach products, protect your eyes and skin.


The object of art is to give life a shape.

—WILLIAM SHAKESPEARE


IMPRINT

Imprints of objects create an interesting perspective to accent your art. Look around to find unexpected and unusual possibilities. Rummage around to find objects for creating innovative imprints; places like your junk drawer, kitchen, garden, even your local farmers' market may yield wonderful treasures for this purpose.

You can dip any implement in acrylic paint, gesso, or inks to create a stamped impression that will add interest to your art. The sky's the limit if you dare to play.

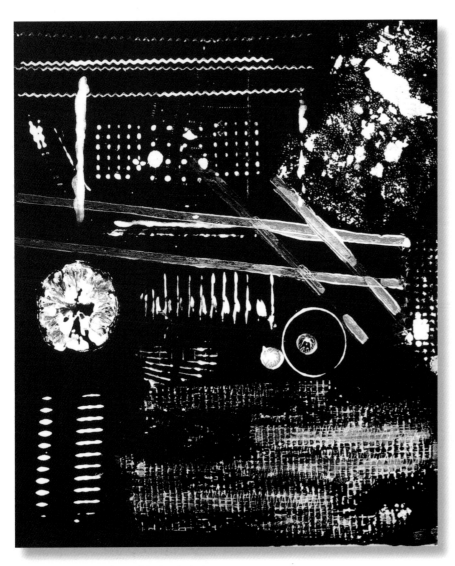

Gesso imprint samples on black substrate

SOME THINGS YOU CAN IMPRINT WITH

pasta cutter

Matchbox car wheels

tea strainer

spiral binding

half a lemon

plastic fruit bags

cheese grater

sticks

mugs

strawberry box

forks

bubble wrap

sponges

corrugated cardboard

candy wrappers

shells

stones

hardware (locks, hinges, etc.)

old jewelry

lace scraps

bottle caps

cloth

scouring pad

cast-off toys

PLASTIC AND BUBBLE WRAP

Random textures can be achieved by using plastic and bubble wrap with paint. Because the texturing occurs while you are looking through the transparent plastic, you have some idea of the effect you are creating as you are working. It is reminiscent of the finger paintings we created as children, without the mess!

Plastic wrap sample

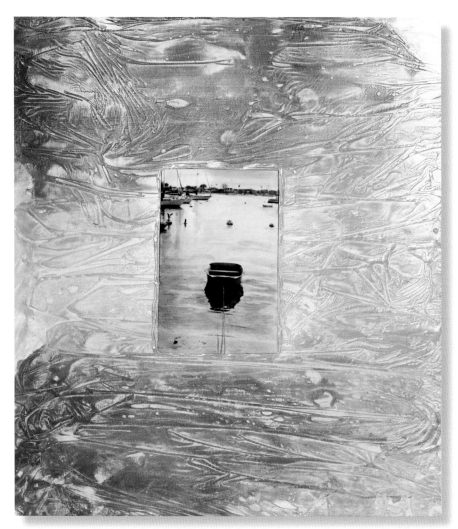

ON GOLDEN SHORE — Black-and-white photograph hand-painted with oils, printed on canvas paper, acrylic paint, plastic wrap

Bubble wrap sample

Project Launch

Choose the color of acrylic, watercolor, inks, or gesso you wish to use. Tear off a piece of plastic wrap or bubble wrap the size of your art paper and set to one side. Lay washes of paint down randomly with a large brush, working quickly so they do not dry. Place the plastic over the washes, smooshing it around to create ridges and open areas. When you like the look, set aside to dry completely. Remove the plastic and you will find a freeform, textural background.

STENCIL

The age-old art of stenciling continues to reinvent itself in art today. At first glance it may not appear that stencils provide dimension or texture, but they can do so in a unique and original way.

STENCIL OVER

A stencil is a template used to draw or paint identical letters, numbers, patterns, images, or symbols every time it is used. Stencils don't have to be store-bought or even designed and cut for that purpose. A wide array of items, such as lace, plastic potato or onion sacks, strawberry boxes, or anything else that creates a physical negative, can serve as a stencil.

On an actual stencil, sections of the template are called islands. All islands are connected to other parts of the template with bridges, or the additional sections of the narrow template material, which are not removed. Stencils are popular for graffiti art, since spray paint can be applied through them fairly quickly and easily. Prefabricated stencil templates are used for home decoration projects and are available from hardware stores, arts and crafts stores, and through the Internet.

Stencils are found worldwide, whether creatively cut from banana leaves, leather, Mylar, quilter's stencil plastic, or wood. For the artist or advertiser, teacher or street artist, wherever quick duplication of images or symbols is desired, from printed fabric to book illustration, from stadium signs to children's handwriting class, stencils are an ideal solution.

STENCIL THROUGH

Project Launch

Secure your stencil and apply light molding paste or crackle paste through it with a spackle knife. Remove the stencil and let the impression dry. A fresco-like image appears, giving it an old-world look. Repeat if you desire a thicker stencil image. Paint with acrylics or sand for another effect.

NOTEWORTHY

• Aerography is a technique in which a three-dimensional object is used as a stencil with spray painting.

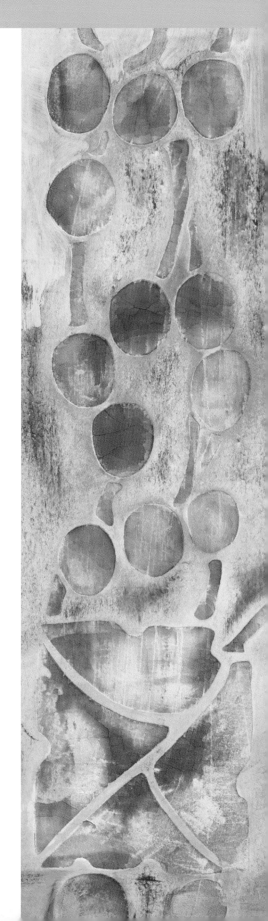

DARD HUNTER GRAPES — Crackle paste stencil image ➤

STENCIL UNDER

A technique that delivers great results is an "accident" that was taught to me by artist Kelly T. M. Kilmer. This is the perfect time to use those not-so-great photographs that you can't seem to throw away. Try this to add wonderful visual texture to a photograph that can be used for collage, as an interesting background, or behind a transparency.

Sanded color photograph samples

Light Bearer — *Transparency over sanded photograph*

Project Launch

Use a color photograph developed in a photo lab and dip it in water for a few minutes to loosen the emulsion. Dry it with a paper towel. Place your image on top of a stencil. The thicker plastic or metal stencils work the best. Lightly rub the surface with sandpaper. The impression of the stencil comes through the photograph, revealing a reverse stencil image. For a layered effect, place a transparency over the top of your "stenciled under" image, as shown in the rightmost image above.

TIMELINE

Theodoric, the illiterate king of the Ostrogoths, uses a stencil of gold ingot to sign his name.

454 to 526

In Europe stencils are commonly used to color old-master prints. The French use stencils to decorate playing cards, books, textiles, and tapestries.

1450

French publishers, influenced by Japanese printed textiles, use stenciling to produce color separations for book illustrations.

1920s to 1930s

"Defense d'Afficher" (Post No Bills) is stenciled throughout Paris, and is still seen today.

1942

Slogans are stenciled on sidewalks.

1990s

4th century

Earliest known stencil designs appear in western China at the Caves of the Thousand Buddhas.

17th and 18th centuries

Europeans immigrate to North America and bring decorative stenciling.

1936

Harper's Bazaar finds it chic to use a stenciled logo.

20th and 21st centuries

Stencils are used by some urban landscape artists to create graffiti.

FIBERS

FABRIC AND FIBER, OVER AND UNDER

There are many wonderful fabrics available today, and they can be incorporated into your artwork just like handmade papers. The weave of the fabric adds a textural quality. Loose threads, achieved by tearing the fabric, can add another wonderful element.

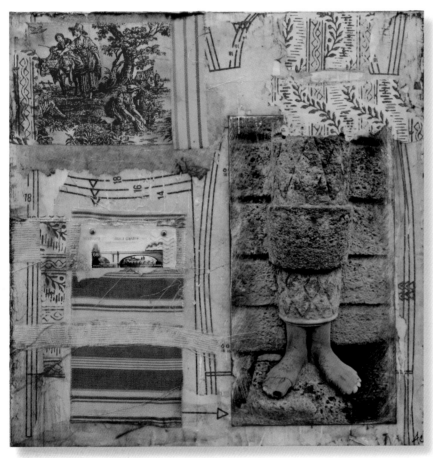

FOOTPRINTS — Black-and-white photograph hand-painted with oil and walnut ink, fabric, handmade papers, sewing pattern, ephemera, brads, postage stamp

TIMELINE

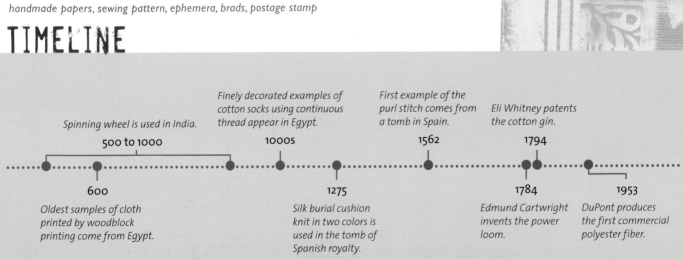

Spinning wheel is used in India.
500 to 1000

Finely decorated examples of cotton socks using continuous thread appear in Egypt.
1000s

First example of the purl stitch comes from a tomb in Spain.
1562

Eli Whitney patents the cotton gin.
1794

600
Oldest samples of cloth printed by woodblock printing come from Egypt.

1275
Silk burial cushion knit in two colors is used in the tomb of Spanish royalty.

1784
Edmund Cartwright invents the power loom.

1953
DuPont produces the first commercial polyester fiber.

FABRIC FUSION

In the past couple of years, yarn, fabric, and decorative fibers have taken a leap into new artistic places. Use fabric as the backdrop for altered pieces, with dangling fibers secured behind to add an element of whimsy. Even the backsides of some fabrics can be as interesting as the fronts. Consider using vintage linens, trims, and ribbons. Don't forget lace samples, which can be works of art in and of themselves.

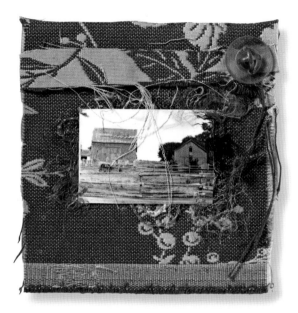

FARM BARN — Hand-painted photograph with markers, fabric, fibers

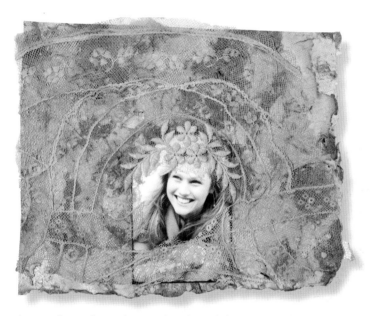

LACED UP — Sepia photograph, walnut ink, lace

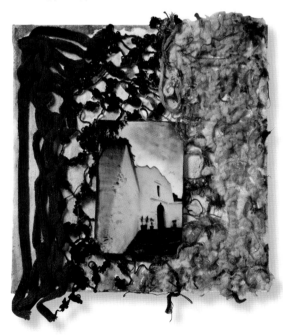

MISSION PERSPECTIVE — Hand-painted photograph with oils, knitted yarn and fibers

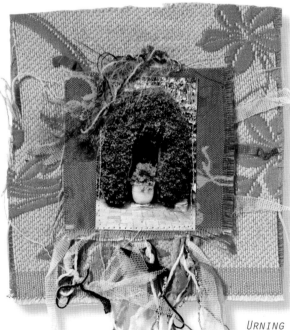

URNING FOR YOU — Hand-painted photograph with markers, fabric, fibers

> Most things in life are moments of pleasure and a lifetime of embarrassment; photography is a moment of embarrassment and a lifetime of pleasure.
>
> —TONY BENN

LAYERS

There are so many papers available today, and all of them can be layered and integrated into your altered art. Card stock, typing paper, newsprint, Kraft paper, construction paper, not to mention a large variety of imported papers, foils, and tissues provide artists with a world of choices.

ARTIST PAPERS

Artist papers make a terrific jumping-off point for your art. There is a large selection of premade papers available at craft and stationery stores and online. Originally, artist papers were made for the scrapbooking industry, but today they are used in all sorts of ways because the choices are so vast. When using them as a background, they can inspire or transform your photographs in a project by creating the mood.

◄ *SUPER KIDS —*
Black-and-white image transparency, vintage photographs, markers, artist paper, clear labels

TIMELINE

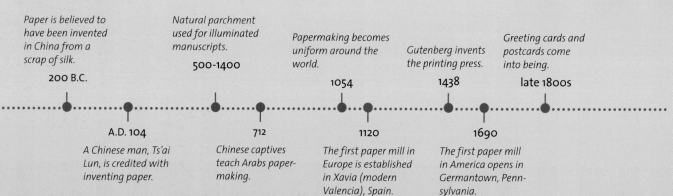

Paper is believed to have been invented in China from a scrap of silk.
200 B.C.

Natural parchment used for illuminated manuscripts.
500–1400

Papermaking becomes uniform around the world.
1054

Gutenberg invents the printing press.
1438

Greeting cards and postcards come into being.
late 1800s

A.D. 104
A Chinese man, Ts'ai Lun, is credited with inventing paper.

712
Chinese captives teach Arabs paper-making.

1120
The first paper mill in Europe is established in Xavia (modern Valencia), Spain.

1690
The first paper mill in America opens in Germantown, Penn-sylvania.

HANDMADE PAPER

There are many wonderful handmade decorative papers that can add plenty of texture to your art. These papers include printed papers, folk papers, marbled papers, and hand-pounded papers. You can use an entire sheet to create a background or tear them to create an uneven edge to accent your images. Paint or ink them to discover the interesting ways they can be enhanced. Oriental and handmade papers can bring an image to life sometimes by using just a snippet, so never throw away small pieces

One of my favorite papers is **rakusui-shi,** "falling water" paper. These delicate white papers come in a variety of openwork lace patterns. When a strong spray of water is forced through a patterned stencil over a single sheet of kozo, these exquisite lace-patterned papers are created. I love how it accepts ink and paint and adds wonderful texture.

◄ *PASSAGE* — *Sepia photograph hand-painted with oils, acrylic paint, inks, rakusui-shi paper, ephemera*

Another favorite of mine is **amate** paper (the border paper on the opposite page) made by the Otomoi Indians of Mexico. They are still producing this outstanding paper the same way they did more than 3,000 years ago, by pounding bark fibers on a wooden board and then drying it in the sun. Organic and durable, it is available in an array of natural and pigmented colors. It withstands paints beautifully and adds a delightful dimensional element. The holes can be placed over or under images, can be used as a border, or can be sewn through.

Joss paper samples

Washi, or **wagami**, is a durable paper made in Japan commonly made using fibers from the bark of the gampi tree, the mitsumata shrub, or the paper mulberry. It can also be made using bamboo, hemp, rice, and wheat.

Joss paper literally means "gold paper." Sheets of joss paper are burned in traditional Chinese deity or ancestor worship ceremonies during special holidays. Traditionally it is made from coarse bamboo paper, although rice paper is also commonly used. Cut into individual squares or rectangles, each square of paper has either a thin piece of square foil glued to its center or is stamped with a traditional Chinese red ink seal.

Mingei means "folk" in Japanese. Mingei paper is traditionally made from handmade mulberry paper, which is dyed, printed, or hand-colored using a hand-cut stencil with patterns that are hundreds of years old.

Hosho first appeared around the fourteenth century in the Echizen Province of Japan. A fine quality hosho is one of the most beautiful of white papers. It does not shrink, tear, or expand and is especially good for woodblock and linoleum printing.

Mulberry is a wonderful versatile paper meant to be torn and not cut. Dampen it with a sponge where you wish to tear it and it leaves a natural deckle edge.

Torinoko resembles an eggshell. It was introduced in Japan around the eighth century, and was made of pure gampi. It is perfect to use for woodcut prints because the quality of this paper will give you a clean print. The Treaty of Versailles was written and signed on this paper because it was believed to be the most permanent paper in the world.

EMBOSSED PAPERS

Manufactured embossed papers can be purchased at most stationery stores and online. The designs embossed into them are deep and clean, and the papers receive paints and stamp pad ink well. Lincrusta and Anaglypa textured wallpapers offer an alternative and will add a new level of dimension and detailed interest to your art.

Embossed paper and paintable wallpaper

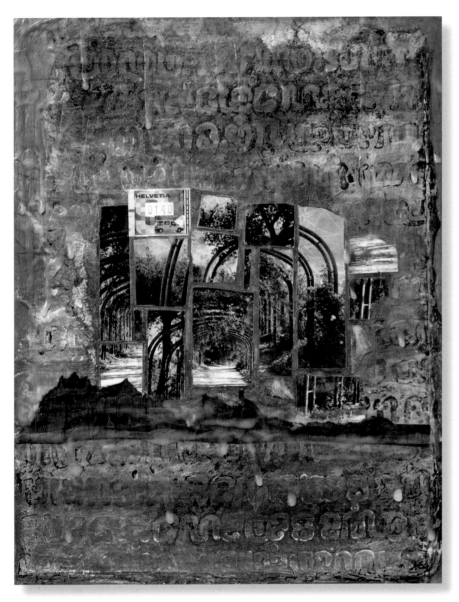

STRUCTURE — *Black-and-white photograph hand-painted with oils, embossed paper, embossing powder, acrylic paint, postage stamp, encaustic*

TIPS

• Exposure to sunlight causes paper to yellow. Store your paper in a cool place without exposure to sun.

• Storing large sheets of paper can be a difficult challenge. Here are some ideas for large paper sheet storage:

• Use skirt hangers that have five or six tiers of clips. You can store about thirty sheets of paper on each skirt hanger, and easily see what you have.

• Use an old wooden bookshelf-style CD rack or scour flea markets for a quilt rack. Several sheets will wrap around the dowels.

• A large art folder works well and can be stored under a bed.

MARBLE PAPER

Marbling is an age-old art used to make paper look like marble. Marbled papers are made by floating oil-based inks on the sized surface of water. Traditional marbling uses carrageenan mixed with water for size, real broom straw to sprinkle the paint, ox gall for the surfactant, and water-based paint or gouache for the pigment. Today, you can buy marbling kits that have added high-grade pigments for rich color and contain an opacity not found in dyes.

Project Launch

You need only a blank sheet of white good-quality paper, a shallow tray filled with water, and some free-flowing water-based paint. Add a few drops of paint or ink on the water, just enough to create a thin layer. Swirl them around carefully with a thin rod to create the pattern you desire, and float a sheet of paper over them. The pigments are picked up and transferred to the paper's surface, resulting in a marbleized pattern. Pull the sheet out and lay it flat to dry. The paper must be strong enough not to tear while immersed in water. Making marble paper is extremely fun, and the sheets you make can be used in your art and bookbinding.

Marble paper samples

TIMELINE

Marbling is believed to have originated in China.

1st century

Suminagashi "ink floating" becomes popular in Japan as a divination tool of Shinto priests, and later as a decorative art.

12th century

The Turkish art of ebru "two-tone marbling" is developed.

15th century

Marbled paper becomes popular used as book endpapers in Europe.

17th century

Marbling becomes a popular handicraft in Europe after Charles Woolnough publishes The Art of Marbling.

19th century

Marbled paper is produced in large quantities in Venice, Italy.

21st century

The difference between the artist and the non-artist is that the artist never stops playing.

—ALEX MOZART

ELEMENTS

Look around when you want to add elements to your art. You probably have plenty of unexpected art elements you can use just for fun. Experiment with how different found objects complement one another and work together. Then look for other elements that can be combined to create contrast and disparity. With art, there are no boundaries.

SOME ELEMENTS TO EXPERIMENT WITH

mesh

cheesecloth

plastic wrap

corrugated paper

DYMO tape

sequin waste

crimped paper

cardboard

wire

labels

paste

tape

rice

table salt

rock salt

sand

eggshells

wax paper

foil

sequins

stickers

glitter

copper tape

gauze

tissue

paper towel

confetti

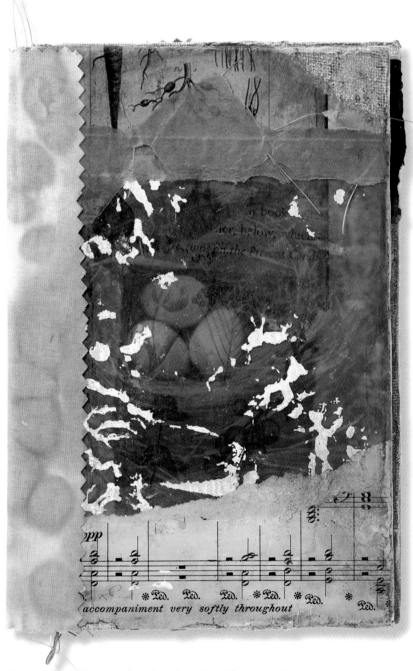

LULLABY — Vellum, acrylic paint, inks, walnut ink, gesso, cotton cloth, sewing tape, ephemera

CORRUGATED CARDBOARD

Corrugated cardboard is the simplest of materials, yet it allows fantastic results when painted. You can also mimic its look with a paper crimper if you want a particular paper or image to have this distinctively ridged style

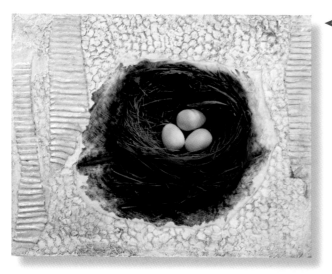

◄ *NESTING — Black-and-white photograph hand-painted with oils, molding paste, rubber stamp, corrugated paper*

TIP

• To obtain straight, remarkably accurate lines, use white plastic artist's tape. Place the tape firmly on your substrate (it can go on top of an already painted acrylic surface). Smooth the edges down tightly with a bone folder or palette knife. Apply your paint, slightly overlapping the tape. Remove before the paint or medium fully dries by slowly lifting the tape up in the opposite direction of the way it was placed. Thick paint or texture gels can be applied this way and you'll get perfectly straight edges every time.

TAPE

Tape comes in many colors, widths, and textures. Place it on your substrate and paint over it. Scrunch it up and flatten it out before painting over it for a textured display. Paint it, let it dry, and then remove it, or have the tape become a part of your art by taping images in place. Colored tapes, electrical tape, and DYMO label tape can add just the accent you need. Clear tape can give a distressed look or age a piece. Dampen an image and apply tape; when it's dry, peel it off. It will take some of the image with it. This can also be accomplished without dampening but the end effect will be more radical.

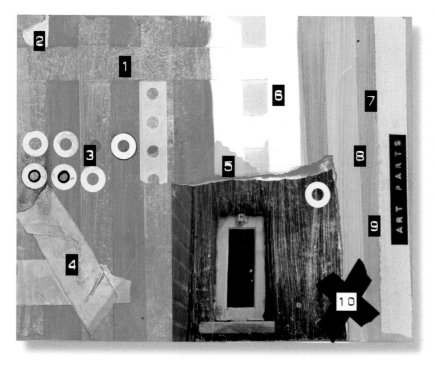

1. *Paint over tape*

2. *Tear tape away*

3. *Reinforcement labels*

4. *Paint over crumpled tape*

5. *Use colored tape over your images*

6. *Mask off areas with tape*

7. *Create straight lines or let the paint bleed under tape*

8. *Paint surface, apply tape, paint and remove tape*

9. *Say something with DYMO tape*

10. *Tape your images onto your art*

SALT, SAND, AND EGGSHELLS

Texture doesn't only impact the look of a piece of art, but also how it feels when actually touched. Besides the wide variety of texture pastes that can be bought commercially, you can also create texture with a few things found around the household or at the beach.

Project Launch

Here are several ways to integrate unusual materials into your artwork:

- Add molding paste to your substrate and sprinkle sand, salt, or eggshells into it. Apply ink over the top of the paste and watch as the ink sinks into, and envelops the material.

- Paint with acrylic paint and sprinkle sand, salt, or eggshells into the paint before it dries.

- Drip glue over your substrate and add sand, salt, or eggshells.

- Mix all three materials with oil paints, apply it to canvas with matte medium, and paint over it afterwards.

- Highlight the ingredients you have added with a paint pad or oil stick.

- Paint a surface with acrylic paint and add table or rock salt. Let it dry, and then brush away the loose salt to leave a bubbly effect.

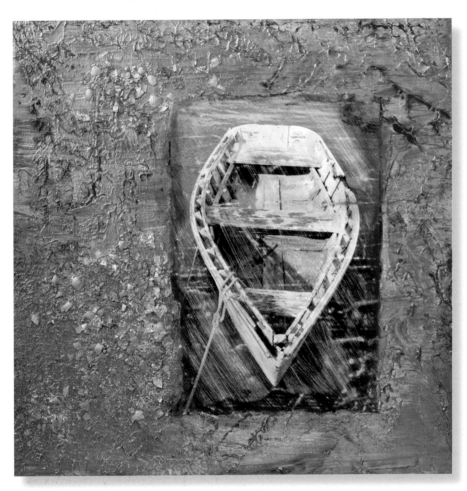

MORE — *Black-and-white photograph hand-painted with oils, acrylic paint, molding paste, pigment ink stamp pads, eggshells, sandpaper, mesh*

TIMELINE

Earliest use of mica is used in cave painting during the Paleolithic period. Mica is known to Aztec, Egyptian, Greek and Roman civilizations.

40,000 BC to 10,000 BC

1st millennium AD

At the ancient site of Teotihuacan, a one-foot thick sheet of granulated mica covers the entire top level of the Pyramid of the Sun.

The French alter the Venetian word zecchin to sequin.

13th century

Turkey introduces a gold coin known as the sequin as a way to display and store families' wealth.

1478

1535

Malta introduces its version of a gold coin known as the sequin.

Schmaltz is the technical term among sign-makers for roadside signs in which the design was made of large sequins that trembled and caught the light.

20th century

1945

Glitter is invented by Leonard Ruschman on his hereford cattle farm in New Jersey. Today the company he founded is the world's leading manufacturer and supplier of glitter.

Scrap and flake mica is produced all over the world.

21st century

MICA

Mica is from the Latin word *micare*, which means to shine. Mica is a mineral crystal known for its transparency and brilliance. It is flat and can easily be split into very thin, flexible layers. Its earthy, natural markings have made it a perfect material for use in altered art. Holes can be drilled in it with a screw punch, for attachment to canvas or paper. When placed over images, a layer of mica adds unique luster and beauty.

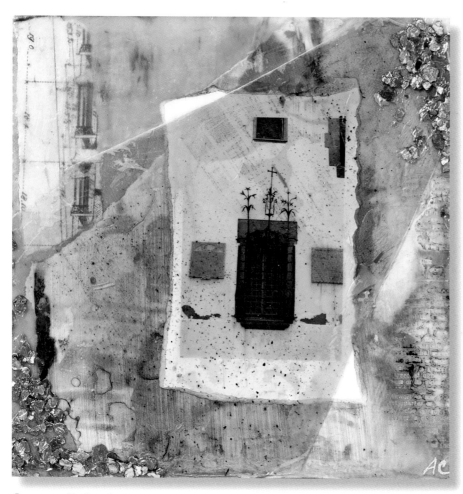

BLEST — Black-and-white photograph hand-painted with oils, mica, walnut ink, mica flakes, ephemera

GLITZ

Putting on the glitz can bring life to your art when it needs that certain sparkle.

Sequins *are shiny and colorful, often found in shapes and used for decoration on clothing, jewelry, bags, and other accessories.*

Sequin waste, *also known as punchinella, is the material left over after sequins have been punched out. It has been discovered by artisans for use on altered art and book pages, or as a stencil for creating backgrounds.*

Glitter *is made of very small pieces of paper, glass, or plastic painted in metallic, neon, and iridescent colors. It is often put into cosmetic products, creating glittery lip gloss and eye shadow. It is commonly used in craft projects and on Christmas decorations.*

Glass shards *are made of real glass and add a timeless look to art. Using them will add a retro cool and glitzy element to your art.*

Micro beads *(also known as tiny glass marbles) are teeny beads or marbles that are a wonderful addition to spill on your art to add texture and tactile appeal.*

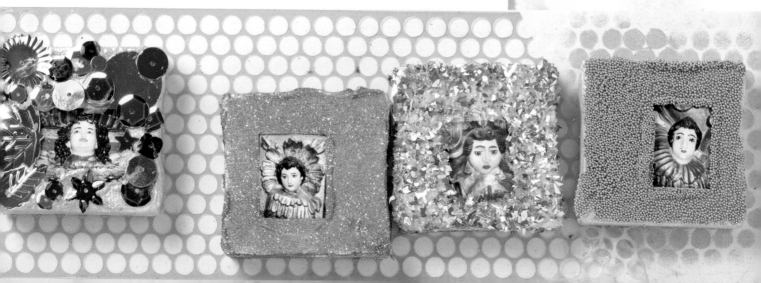

You've gotta be original, because if you're like someone else, what do they need you for?

—BERNADETTE PETERS

EPHEMERA

Ephemera is defined as something of no lasting significance, and also as paper items (as posters, broadsides, and tickets) that were originally meant to be discarded after use but have since become collectibles.

Bits of ephemera are captivating components to keep in your artist's toolbox. Ephemera is everywhere. Whenever and wherever I travel, even in my own neighborhood, I pick up bits and pieces as I go. My friends save intriguing and unusual tickets, coasters, and business cards from exotic places and bring them to me to incorporate into my art.

Rejectamenta are made of things or matter rejected as useless or worthless. You probably have ephemera or rejectamenta lying around your house and may not even realize it. Old report cards, postcards, playing and trading cards, music sheets, maps, letters, stock certificates are examples. The list is endless and the art you can make with them is too.

Ephemera samples

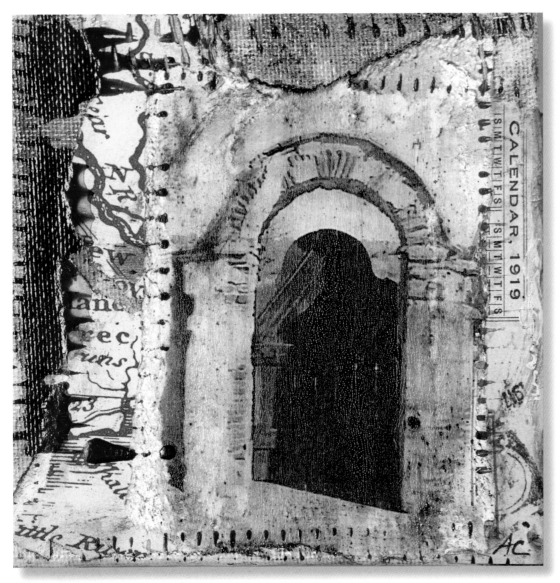

1919 — Black-and-white photograph hand-painted with oils, acrylic paint, ephemera

TISSUE, NAPKINS, AND NEWSPAPER

Crumple, fold, and play with tissue and decorated napkins. Their thin texture is ideal when you need a background or snippet of interest. I love the look of newspaper peeking from behind photographic images or under layers of paint. You can use matte medium for an easy application of layers.

Tissue, napkins, and newspaper sampler

TIPS

• Apply paint with newspaper by dabbing or smearing your substrate. The ink on the newspaper mixes with the colors to create dynamic patterns.

• Another technique to employ after applying your paint is to remove it with newspaper for a dappled, black-ink appearance.

• Store pretty tissues you may receive with a gift, and collect napkins to use on the perfect project. Place them over your images and apply matte medium. Watch the tissue become transparent, revealing underlying imagery, or laying on another pattern that transforms your image.

DETERIORATE

There is something intriguing about old things, such as paper that has been tarnished and aged and elements that seem to have lived a life in some faraway place. Modern Masters Metal Effects products easily create this aged look. In my art, I particularly like using embossed papers that have been aged using these effects because the inherent texture of the paper emphasizes the metamorphosis so beautifully.

RUST

Ah, that fabulous old rusty feeling! How great it is that a time-weathered element can be created like magic with products available today.

Project Launch

Apply two coats of Metallic Iron Effects paint to your substrate. This paint has real iron particles that will tarnish over time, but by adding the rust activator, an authentic weathered rust finish will develop almost immediately. When your base is dry, apply the rust activator with a brush, sponge or spray gun. Let it dry completely. Rust can be created on metal, wood, plaster, canvas, paper, or plastic surfaces.

PATINA

This aging process can be transplanted onto your artwork with a little help. Different patinas are obtained by using different metallic base coats and different patina or aging solutions: Pale Gold, Rich Gold, Harvest Gold, Copper, or Bronze with either Blue or Green patina. These looks will transform many surfaces into an ancient-looking artifact in two easy steps.

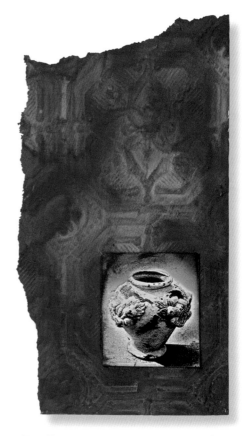

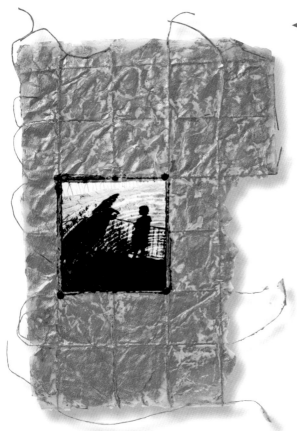

◄ *THE STORYTELLER —* *Black-and-white photograph hand-painted with oils, rice paper, metallic paint, patina solution, simulated liquid leading*

THE URN — Black-and-white photograph altered in Photoshop, embossed paper, rust solution

▲ When using Metal Effects solutions, check out the back side of your paper. You may find it has absorbed the product differently than the opposite side and can be equally intriguing.

CRAQUELURE

Fabulous crackle effects are attained by painting your surface with a china crackle water-based medium. Three easy steps achieve this complex surface effect.

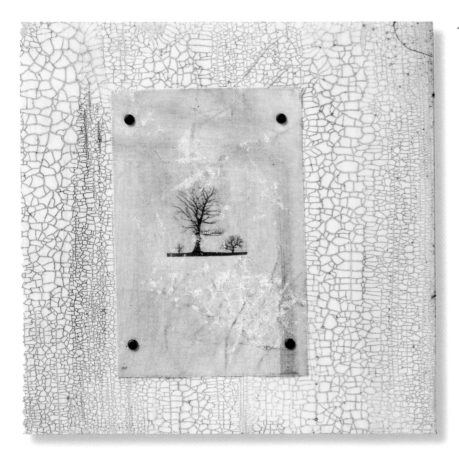

◄ *BARE BONES* — *Black-and-white photograph made into an etching, printed on canvas, china crackle, dark china crackle enhancer*

Project Launch

Apply the crackle base coat to your painted substrate. Let dry for one hour (it should feel rather tacky to the touch). Apply the crackle topcoat, brushing only once over your surface. It will dry clear in one to two hours. Apply the crackle enhancer with a soft cloth to accent the cracks. Choose the light color for dark surfaces and the dark color for light surfaces.

◄ *TREE MUSIC* — *transparency, china crackle, light china crackle enhancer*

MOSAIC

By juxtaposing various sizes and sections of your photographs, you can create a whole new picture and tell a unique story with pieces of imagery.

CUTTING AND RECONFIGURING IMAGERY

Photographic mosaic, also known as Photomosaic, a portmanteau of photo and mosaic, is a picture that is divided into small sections. When viewed as a whole, it appears to be one image, when in fact the image is made up of hundreds or even thousands of smaller images. Photomosaics are primarily created digitally, but can also be created with a vivid imagination, a photograph, and a pair of scissors. Cubomania is a method of making collages in which an image is cut into squares and the squares are then reassembled without regard for the original image.

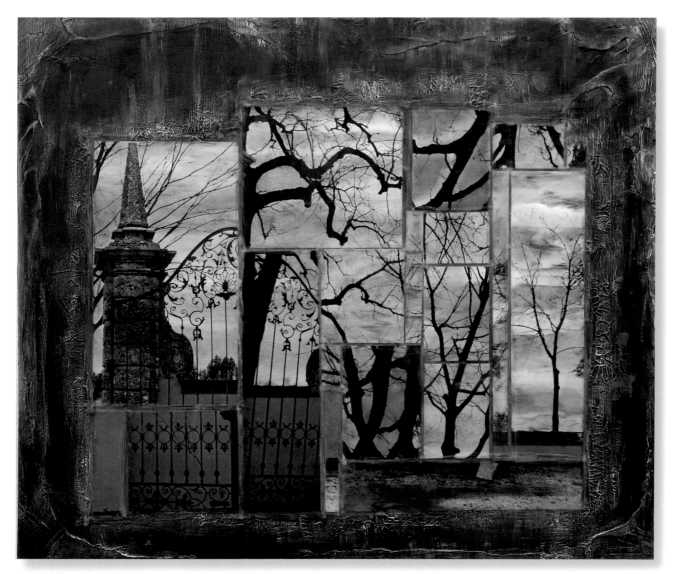

GATEWAY — *Black-and-white photograph hand-painted with oils, acrylic paint, embossing powders, molding paste, encaustic wax*

MESSAGE — Black-and-white photograph hand-painted with oils, acrylic paint, molding paste

Cut or tear images into squares or strips and weave them together as shown in the image. I took scissors to a 20"x 24" (50.8 x 61 cm) photograph that I hand-painted in oil and wove it into an entirely different image at left. Taking scissors to a photograph can be a bit unnerving, but trust that your sense of design will ultimately make it all fall into place.

Project Launch

Here's how to mosaic your photographs: Peel the back off an 8 1/2" x 11" (21.6 x 27.9 cm) sticky label, and place it on your work surface sticky side up. Cut and tear images randomly, placing them on the label, leaving a space between each photograph. Pour embossing powder generously over the photographs, pressing it into the gaps between them. Tip the excess powder off onto folded card stock and pour it back into the jar. Carefully clean excess powder from the surface of the photographs with a dry brush. Turn on your heat gun and keep it in constant motion as you melt the embossing powder. As you heat them, hold an index card in your other hand over your photographs so they won't blister. Try stamping into the embossing powder for an additional effect. Let your art cool completely before flattening between phone book pages. Several mosaics can be connected together using embossing powder as the border between each one.

TIMELINE

Mosaics are used for pavements.

8th century B.C.

4th century B.C.

Well-to-do Greeks have their floors covered in elaborate mosaics.

Mosaic spreads through the Hellenistic world and is brought by Greek craftsmen to Italy, evident in amazing examples from Pompeii.

1st century B.C. to 3rd century A.D.

4th century

In a turning point for mosaic as an art form, Christians decorate the walls of churches rather than the floor.

Space scientists stitch together a series of adjacent pictures of a scene to create space Photomosaics.

1950s

1995

Robert Silvers creates a Photomosaic, and goes on to trademark the term.

There are always two people in every picture: the photographer and the viewer.

—ANSEL ADAMS

TEXTILE PRINTING

Printing on fabric has become as easy as owning a good printer and buying printable fabric sheets. With this technology you can print images of new and old photographs, letters, and even fabric to use in your next art project.

ORGANZA

Organza is a thin, plain-weave, sheer fabric traditionally made from the continuous filament of silkworms. Though many organzas are woven with synthetic filament fibers such as polyester or nylon, there are luxurious organzas still woven with silk. Silk organza is woven in Zhejiang in China, a coarser silk organza is woven in India, and deluxe silk organzas are woven in France and Italy.

Organza can be run through a computer, so this sheer thin fabric can be used in your art. You can print images or text and it is perfect when you want a dreamy, illusive interpretation of an image that can be placed on top of a textured background.

• After printing your image on organza sheets, pull the threads on the sides to make them fray and soften the hard edges.

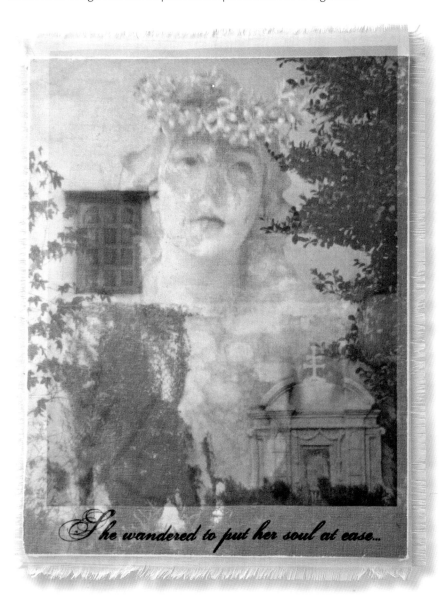

She wandered to put her soul at ease...

◄ SHE WANDERED — Black-and-white photograph printed on organza, oil pastels, artist paper

SILK

Silk is a "natural" protein fiber — the strongest natural fiber known to man. The appearance for which silk is known comes from the fiber's triangular prism-like structure, which allows silk cloth to refract incoming light at different angles. This soft, lustrous fabric, which is hand-washable and super-soft, can now be purchased in sheets to run through your computer. Attached to your art, the texture of this luxurious fabric can be viewed and appreciated. ▼

COTTON

The word cotton comes from the Arabic *qutun*. An ancient material that still is a favorite today, cotton produces a crisp, clean image just like the material itself. Cotton sheets are now available to feed through your computer, and once the back paper is removed it generously accepts inks, paints, and dyes, and yields endless possibilities. ▼

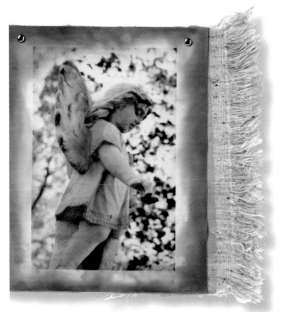

MONICA — *Black-and-white photograph hand-painted with oils photocopied on silk, vintage brocade fabric*

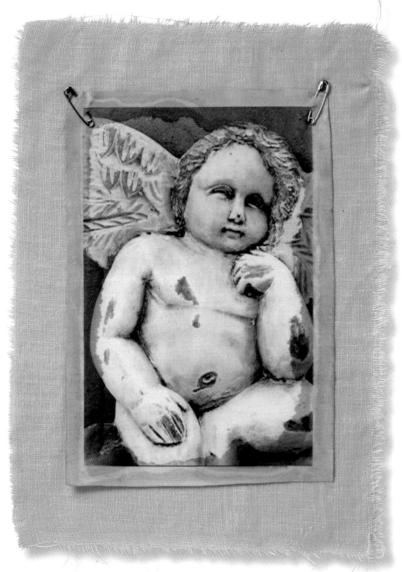

PLACIDA — *Black-and-white photograph hand-painted with oils photocopied on cotton, inks, linen*

CANVAS

Canvas prints can be produced with either an inkjet or a dye-sublimation printer. With inkjet prints, the ink is on the surface of the canvas, whereas with dye sublimation, the ink penetrates the canvas. The availability of canvas sheets that can run through a home computer make it a perfect product to use in your art.

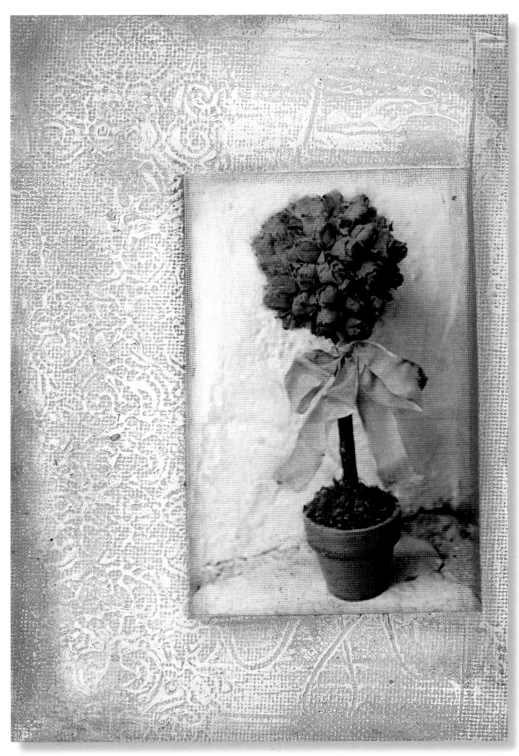

THE PROMISE — Black-and-white photograph hand-painted with oils photocopied on canvas, acrylic paint, gesso, oil pastels, rubber stamp

TRANSFERS

There are many techniques for transferring images, some of which are quite complicated and messy. Transparency transfers and iron transfers are two techniques that produce good results every time.

Project Launch

Method 1 (see Celeste example): Use an inkjet printer to print your image onto transparency film and let it dry. Apply a thin layer of TranzIt with your finger or brush to the printed side of the film. Place TranzIt facedown onto your surface and burnish evenly with a bone folder or burnishing tool. Let it sit for five minutes and peel away the film when the image has been transferred. The slightly imperfect look is a wonderful addition to any art piece.

Method 2 (see Wing and a Prayer example): One of the simplest and most mistake-free transfer techniques is the traditional iron-on transfer, which is for clothing, but don't let that stop you! Iron-on transfers can be transferred to any fabric or paper and can then be used in your artwork.

Unless your image fills the whole sheet of transfer paper, fill the sheet with several images that you can use later. Text will need to be reversed; don't forget to flip it in the computer so it will read correctly once transferred. You will also need to flip your image if you want it to face a certain direction.

Each package will have its own instructions to follow, but the basic procedure is to print an image onto the printable transfer sheet and cut it out. Apply it to an ironed piece of fabric covered with baking parchment paper using a hot iron with no steam to transfer the image. Let it cool and peel off the backing. Voila!

CELESTE — Black-and-white photograph transfer

TIP

• Experiment transferring to different colored fabrics and papers. I pull my fabric transfers to create cracks so they don't have such a "perfect" look. I like the tears and peeling that occur when manipulated. I fill in the fissures with a paint stain. Try using transfer sheets on canvas paper, handmade paper, or book pages. Each will present a unique variety of effects.

◄ *WING AND A PRAYER — Sepia photograph , T-shirt transfer, linen fabric, walnut ink*

> I try to apply colors like words that shape poems, like notes that shape music.
>
> —JOAN MIRO

TEXT

Text is a wonderful asset in a piece of artwork. There are a wide variety of artist papers, book pages, and ephemera that offer unique printed text. Downloadable computer-based fonts allow you to say whatever you wish, in almost any style of writing you desire. You can even create a computer font from your own handwriting.

DOROTHY — Vintage photograph, papers, transparency, ledger paper, text, embossing powder

TIPS

• Use text as an overlaid design element to meld other elements together.

• Make a calligramme (text or poem) in which the words or letters form a particular shape.

• Cut your text up randomly and rearrange it, thereby creating totally new text.

• Don't be reluctant to use your own handwriting or printing. You don't have to be a perfect calligrapher to say what you mean, and you will add an inimitable element to your art.

• Write into gesso or molding paste, creating patterns and ridges.

• Start a file of your favorite sayings and quotations—they can be a terrific inspiration.

TIMELINE

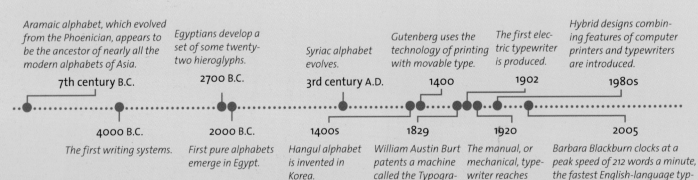

Aramaic alphabet, which evolved from the Phoenician, appears to be the ancestor of nearly all the modern alphabets of Asia.
7th century B.C.

Egyptians develop a set of some twenty-two hieroglyphs.
2700 B.C.

Syriac alphabet evolves.
3rd century A.D.

Gutenberg uses the technology of printing with movable type.
1400

The first electric typewriter is produced.
1902

Hybrid designs combining features of computer printers and typewriters are introduced.
1980s

4000 B.C.
The first writing systems.

2000 B.C.
First pure alphabets emerge in Egypt.

1400s
Hangul alphabet is invented in Korea.

1829
William Austin Burt patents a machine called the Typographer.

1920
The manual, or mechanical, typewriter reaches a standardized design.

2005
Barbara Blackburn clocks at a peak speed of 212 words a minute, the fastest English-language typing in the world, according to the Guinness Book of World Records.

RUB-ONS

One easy way to add text to your art is with rub-ons. They come in all shapes, sizes, and colors, as quotations, alphabets, and design elements. Rub-ons are applied by burnishing a design with a bone folder or Popsicle stick onto your work surface. When they are applied they have a very clean look, almost as if the image is hand-drawn, or written. Rub-ons are available at scrapbooking and art stores and online.

BE STRONG — Acrylic paint, transparency from hand-painted photograph, stamp pad ink, rub-ons

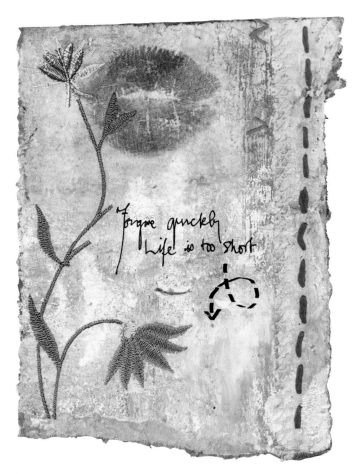

FORGIVE — Acrylic paint, lipstick, tissue, rub-ons, stamp pad ink

TIPS

- Try using rub-ons directly on your pictures.

- Don't use a rub-on in its entirety; use only a portion of a word or design.

- Use rub-ons to create a visual frame around an image.

- Apply a little metallic pigment over your rub-on for a glistening effect.

- Use a photograph of a wall and cover it with rub-on graffiti by placing rub-on words haphazardly.

Cut out the letters or words from both the plastic overlay and the backing of the rub-on before applying. This will prevent you from accidentally including any part of the rub-on you don't want. Design elements can be used as they appear, or they can be altered with a bit of clever trimming. Use a bone folder or Popsicle stick and burnish evenly. If you use too much pressure, it may indent your art or image.

Project Launch

To create your own rub-ons, first design an image on your computer. If you are printing words, reverse the print so they will read correctly. Print the document as a transparency; this deposits a thicker amount of ink. Make sure you print on the slick, shiny side. Let it dry. Don't touch it or the ink will smear. Place the design ink-side down over your artwork and use a bone folder or stylus to transfer your image. Peek to make sure all the ink has transferred before removing the transparency. Let it dry completely. If you find it has smeared on your paper, a clean, sharp eraser will tidy up those areas. Spray with a fixative. Clean off the transparency sheet with a baby wipe and use it again. Making your own rub-ons opens a new door to altering with the text and decorative embellishments you choose.

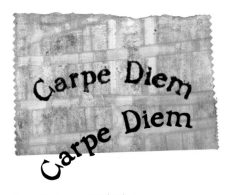

Computer-generated rub-on

SKETCH, DOODLE, AND DRAW

The art of doodling has been revived with the popularity of journaling and the eager adoption of the classic look of black ink drawing by mixed-media artists. Sketches, quick drawings on napkins or scraps, and doodles made while on the phone can all find their way into your art or journals. Consider using a pen that produces raised ink to add a nice dimension to your written words and sketches. These pens are available at most stationery stores.

Take a charcoal sketch class and use parts of your sketches in your art or try sketching from photographs you have taken. It doesn't have to be perfect to be interesting.

Using charcoal can create visual textures on your artwork. Don't be afraid to combine charcoal sticks with other media.

Graphite pencil sketches

LIZI SKETCH — *Graphite pencil sketch, enhanced in Photoshop*

KIMI SKETCH — *Graphite pencil sketch, enhanced in Photoshop*

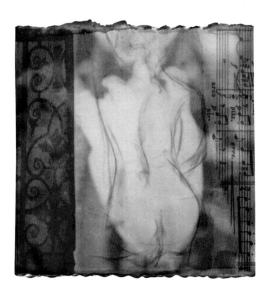

◄ BLOSSOMING — *Black-and-white photograph hand-painted with oils, charcoal sketch, sheet music*

GRAPHITE PENCILS

Pencils are not just for details. Graphitint water-soluble graphite pencils are available with colors that are soft and subtle, ranging from soft shimmering grays, blues, and greens to fantastic russets, plums, and browns. When used dry they exude the softest hint of color, or add water and the color becomes more vibrant. Different papers will produce a different blend of colors. If you love the feel of a graphite pencil, you will love experimenting with these to color your images.

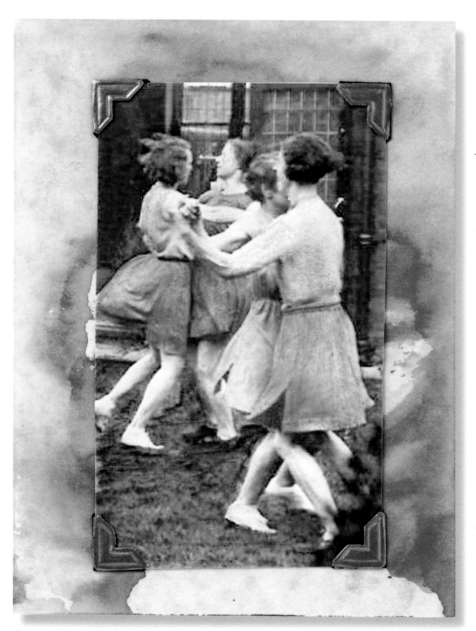

HAPPINESS — Black-and-white vintage photograph printed on watercolor paper, painted with watersoluble graphite pencils, ink, photo corners

NOTEWORTHY

• Pencils are graded according to how hard or soft they are. The higher the number, the harder the pencil. "H" pencils (H, 2H, 3H, etc.) are hard pencils. Hard pencils make light lines that can easily be erased and are excellent for fine detail work. "B" pencils (B, 2B, 3B, etc.) are soft — the higher the number, the softer the pencil. Soft pencils make a softer line and can be smudged for shading.

TIPS

• Use a bleach pen to make doodles over your painted backgrounds.

• Think big and let your words run off a page. Use a calligraphy pen for thick and thin lines.

• Make your sketches and scan them into the computer to alter and color them.

• Print your doodles or sketches on transparencies or fabric to use in your artwork.

• Get in the habit of sketching the simple things around you. Start a journal.

SEE, EXPLORE, ABSORB

PORTFOLIO OF ART

> Every artist dips his brush in his own soul, and paints his own nature into his pictures.
>
> —HENRY WARD BEECHER

C.W. SLADE

From the studios of some of my favorite artists, I have chosen this gallery of unique pieces that highlight their inventive spirits. There are twenty-one artists, and twenty-one different interpretations of altered art techniques for photographic imagery. Each artist presents his or her musings for our viewing pleasure and inspiration.

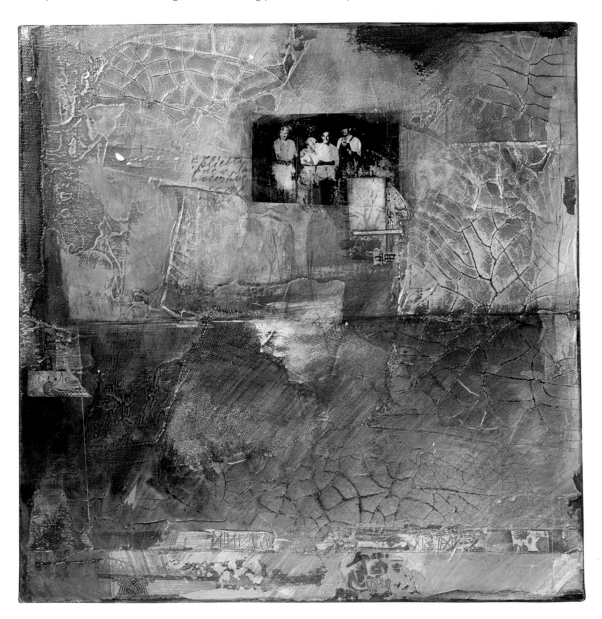

THE GUARDIANS

Digitally altered photo, Golden Crackle medium, acrylic paint, gloss medium, collage material

DERYN MENTOCK

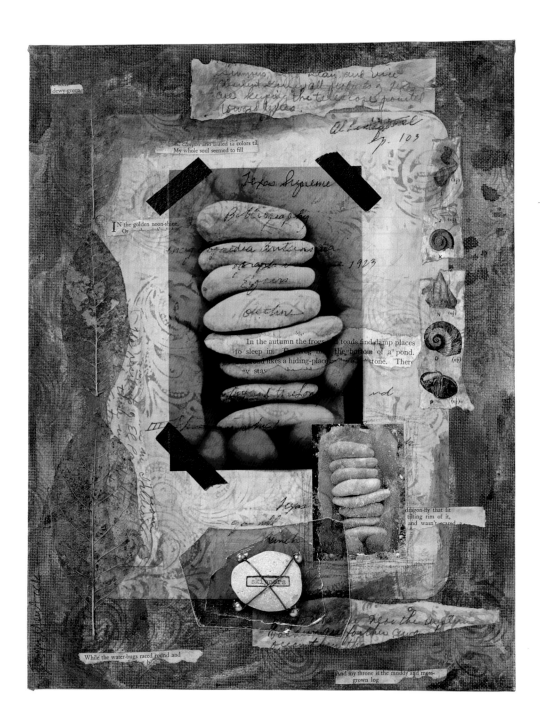

SKIPPERS

Photographs printed onto transparency sheet, photograph printed onto photo paper
then transferred onto bristol paper using water, handmade stamp, antique school
papers, skeleton leaves, mica, stone, tape, wire, walnut ink, and paint

SARAH FISHBURN

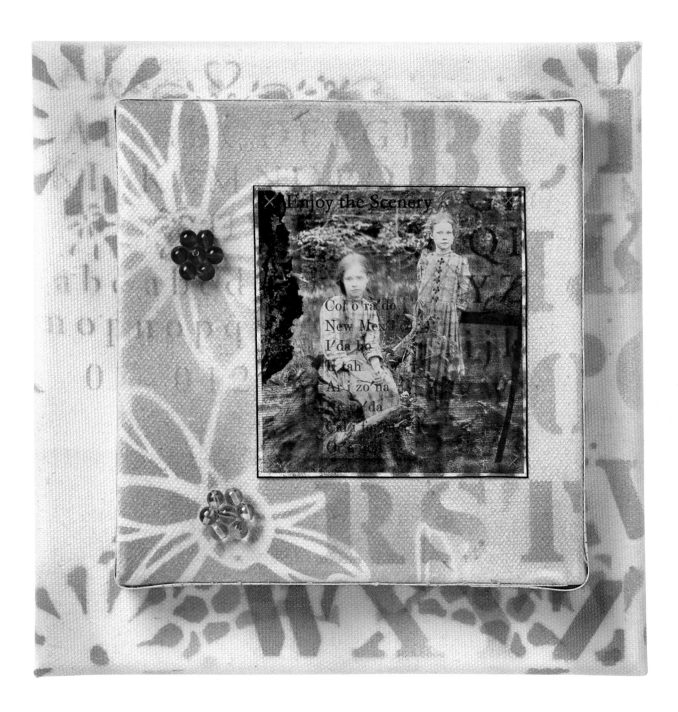

ENJOY THE SCENERY

Two square wrapped canvases, Photoshop-altered vintage photo transparency, printed words, embroidery thread, glass beads, alphabet stencil, Heidi Swap Daisy mask, spray paint

MICHELLE WARD

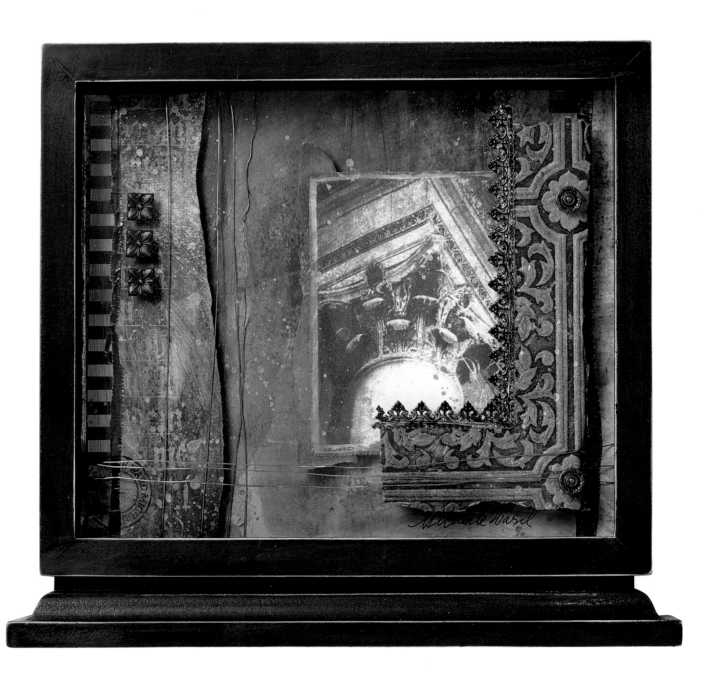

SANS FLUTE

Toner-transferred photograph printed onto fabric, foam core, acrylic, gesso, papers, Anaglypta (textured wallpaper), German embossed scrap, copper wire, copper tape, copper brads

TIFFINI ELEKTRA X

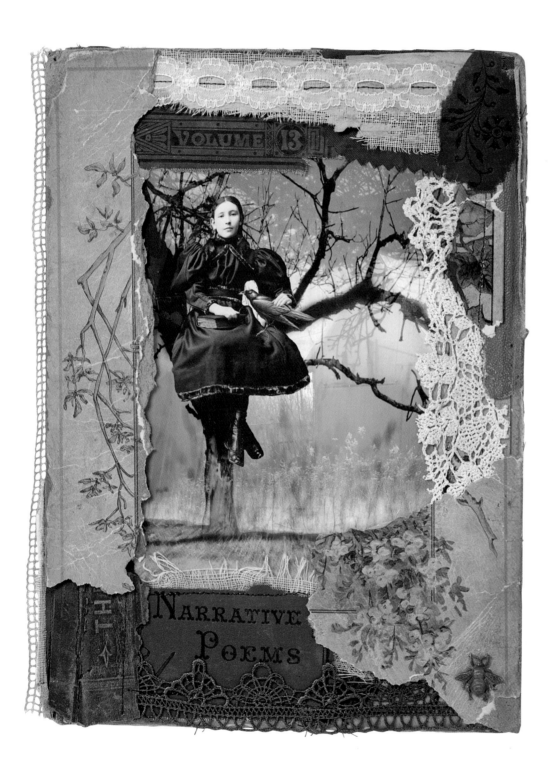

THE GIRL AND THE RAVEN

Digitally altered vintage photograph, three trees from royalty-free collection of stock photos, antique book covers, found papers, fabric, lace

CLAUDINE HELLMUTH

VESPA GIRL

Paint, ink, photocopies

ANAHATA KATKIN

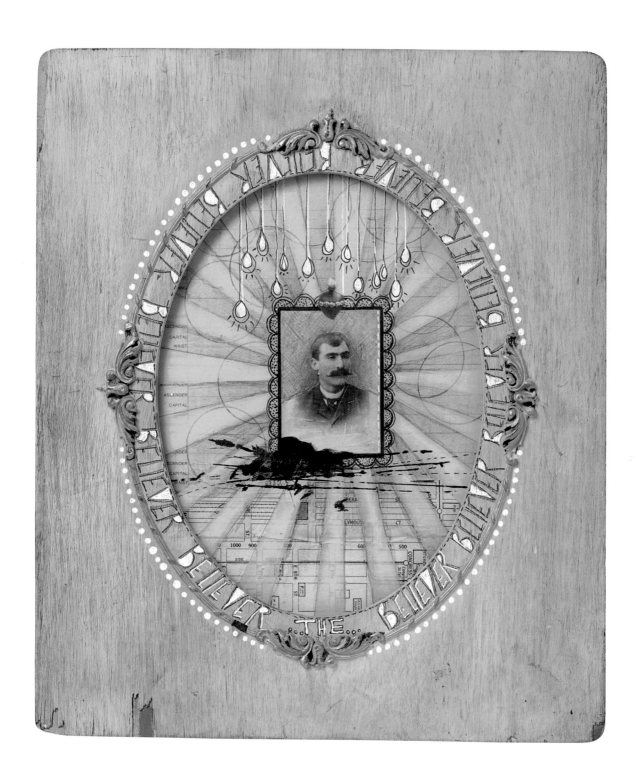

THE BELIEVER

Vintage maps, school paper, acrylic paint, sumi ink, antique photocopied photograph,
pencil, pen, Japanese white Uniball pen, antique frame

SUSIE LAFOND

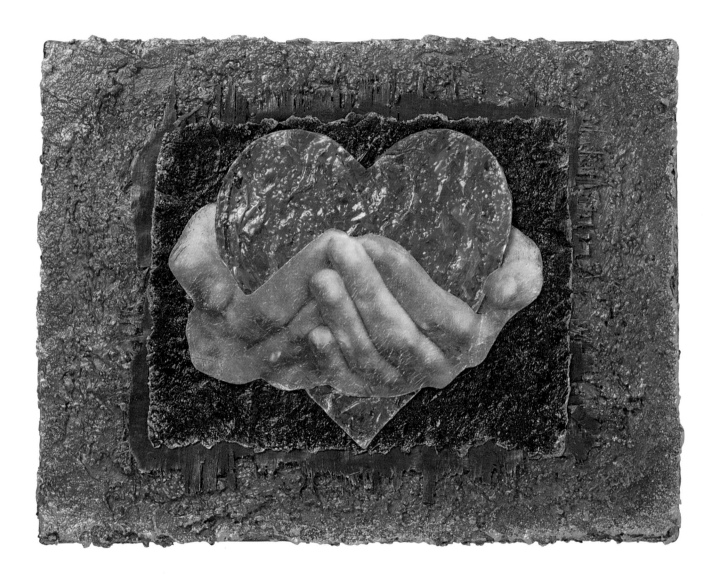

HEALING HANDS

Canvas, photograph, acrylic and Lumiere paints, gel medium, granular gel, black textured paper

LESLEY RILEY

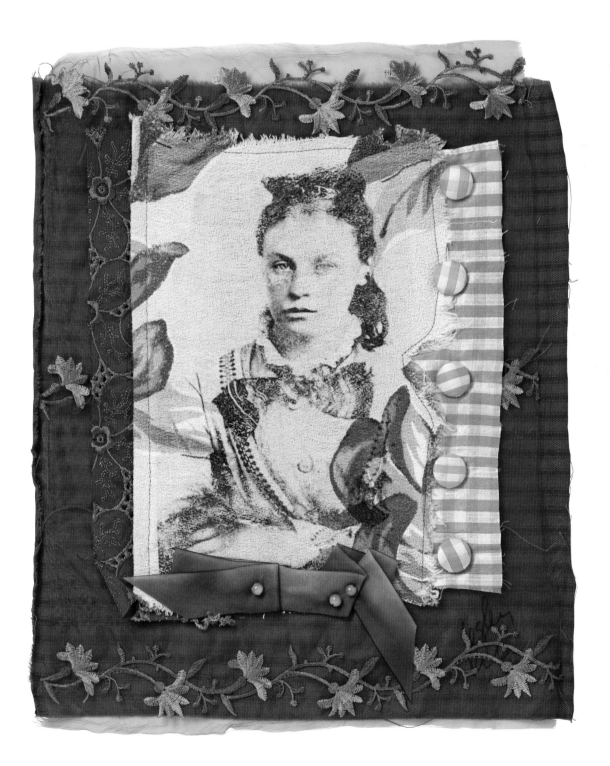

LIESL

Transferred image from antique tintype, matte medium, vintage and new fabric,
silk ribbon, beads

CÉLINE NAVARRO

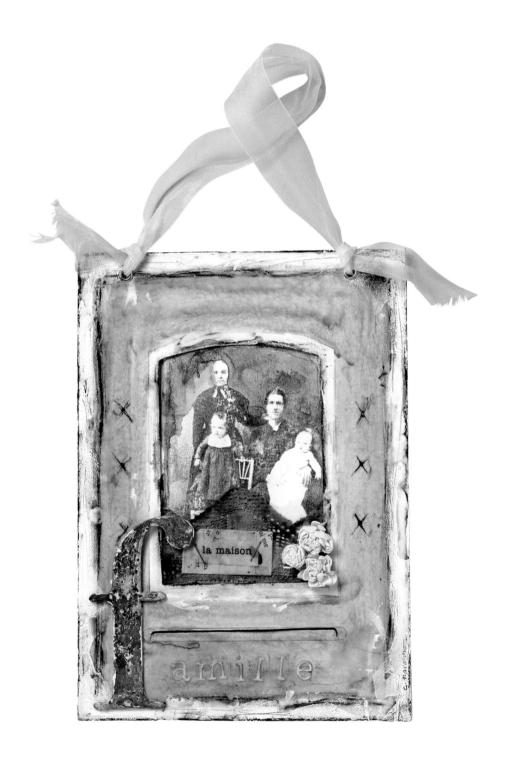

LA FAMILLE

Vintage photo album page, vintage cabinet card, black-and-white photocopy, beeswax, gesso, ARTchix studio fabric sayings, stickers, chipboard letter, lace, oil pastels, wood, ribbons

ERIKA TYSSE

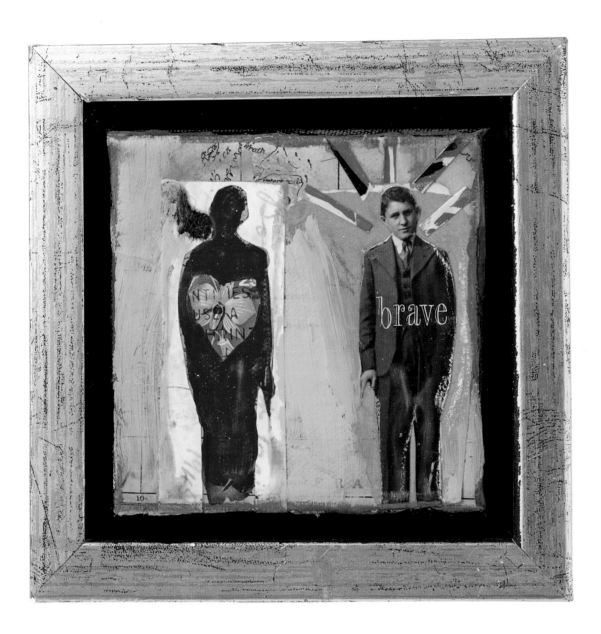

BRAVE

Wrapped canvas, original vintage photograph, found papers, acrylic paint, Caran d'Ache water-soluble wax pastels, Memory Makers rub-ons, Golden matte medium, high-gloss varnish

SHIRLEY ENDE-SAXE

A BREATH, A TOKEN

Vintage photos, gesso, acrylic paint, ink, silk

MISTY MAWN

THE MEADOW

100-percent cotton watercolor paper, acrylic paint, gel medium, inks, printed photographs,
egg stamp from Green Pepper Press

M. RHEUBAN

NO. 162

Mixed-media collage on watercolor paper, photocopy of photograph, tissue paper, ink, acrylic paint, corrugated paper, newspaper, cheesecloth, silver leaf

KELLY T. M. KILMER

FRAGMENTS

Collage, photograph, papers, rubber stamp, Angela Cartwright transparency *Cottage Garden*, tissue, acrylic paint, india ink, Gelly Roll Glaze and Soufflé pens, black VersaFine stamp

ELAINE H. PEARSONS

THE WEDDING PARTY

Altered photography (point-o-graphy), photograph and vintage photograph, fabric, wire
ribbon, acrylic paint

JOFISH

IN MEMORIAM

Vintage photos printed as transparencies, scrapbook paper, coffee filter, handmade paper, fabric flowers, vintage rhinestone locket, two deep inset frames placed back to back, ribbon

SCOTT DAVIS JONES

TREE

Photograph hand-painted with oils grisaille style

TRACI BAUTISTA

GARDENFLOWER

Fusion-dyed collage created manually with black and white laser photographs and doodles combined and digitally manipulated in Photoshop

KATINA DESMOND

VERMILLION INTRIGUE

Black-and-white film photograph hand-painted with oils, rephotographed with color
film, printed in color and scanned, altered digitally

ASHLEY SINCLAIR

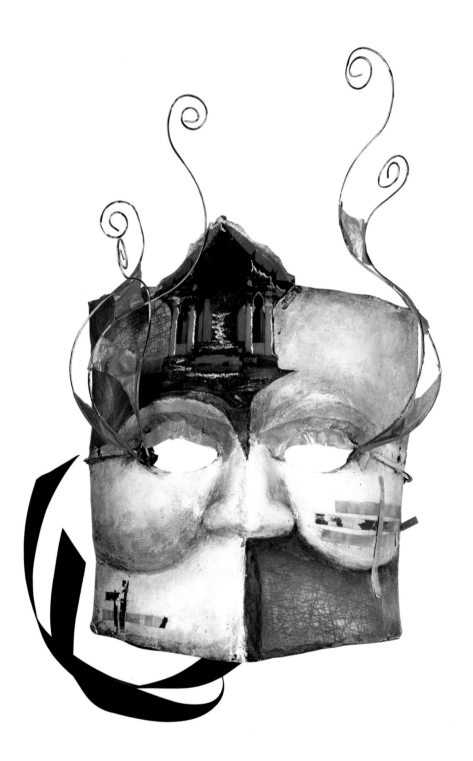

THE DREAMER

Papier-mâché mask from original casting, color digital photographs, acrylic paint, Color-Box Cat's Eyes, florist wire, bronze tissue

CONTRIBUTING ARTISTS

Traci Bautista
www.treicdesigns.com
kollaj.typepad.com

Katina Desmond
www.katinadesmond.com

Tiffini Elektra X
www.tartx.com

Shirley Ende-Saxe
rgrace44223@yahoo.com

Sarah Fishburn
www.sarahfishburn.com
ragtagsf.blogspot.com

Claudine Hellmuth
www.collageartist.com

JoFish
www.sarahfishburn.com/JoFish.htm

Scott Davis Jones
www.4260photo.com/photographers/
sdjones/sdjones.htm

Anahata Katkin
www.anahataart.com

Kelly T. M. Kilmer
www.kellykilmer.com
www.kellykilmer.blogspot.com

Susie LaFond
latwmn.typepad.com/susiesmuse

Misty Mawn
www.mistymawn.typepad.com

Deryn Mentock
somethingsublime.typepad.com

Céline Navarro
thegreenfrogstudio.typepad.com

Elaine H. Pearsons
www.elainepearsons.com

m. Rheuban
www.mrheubanartist.com

Lesley Riley
www.lalasland.com
http://myartheart.blogspot.com

Ashley Sinclair
www.paxartistry.com

C. W. Slade
www.cwslade.com

Erika Tysse
www.erikatysse.com
www.erikatysse.blogspot.com

Michelle Ward
www.greenpepperpress.com

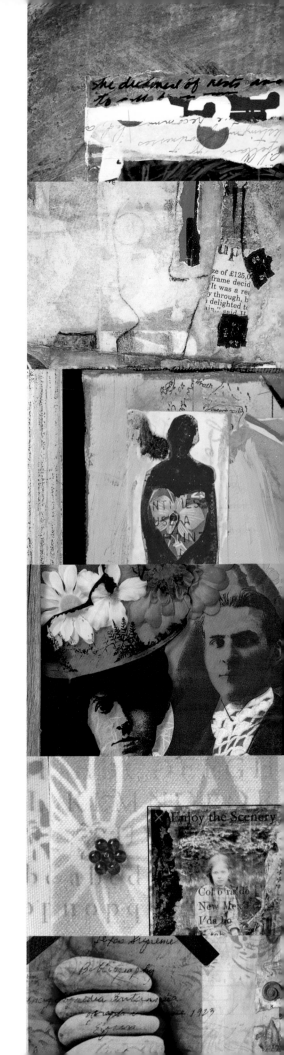

GLOSSARY

acrylic A man-made synthetic material used in fixatives and polymer (plastic) colors.

beeswax An ancient medium for painting; pigments are mixed with molten wax, and applied while hot.

black-and-white Pictures, photographs, and drawings executed in black pencil, charcoal, crayon, or pen-and-ink. Also, a general term referring to fine prints (woodcut, engraving, etching, lithograph, etc.) done in gray tones.

chiaroscuro The distribution of light and shade in a picture.

cockrells Similar to marbled paper where inks are combed into patterns and transferred to paper.

composition The design that holds a work of art together as an inseparable unit.

Drier An oil painting medium for hand painted photographs that speeds up the drying time from one to three days to about six hours.

dry-brush work Strokes of paint that are applied quickly with nearly a dry brush over dry ground or color, leaving previous color showing through.

Duolac A quick drying waterproof varnish for photographs. A smooth satin or glossy effect can be achieved by different brush on methods.

extender A colorless neutral base that can be mixed with oils to reduce their saturation or color strength (more extender yields paler colors). It also can be used for touch-up or clearing color in small areas.

fresco Painting in watercolor on freshly spread, still moist, plaster. The pigments become chemically fused with the plaster.

frisket A mask of thin paper laid over an illustration to shield certain areas.

gesso Plaster (whiting) mixed with a binder, such as linseed or polymer, used as a ground for painting or for creating reliefs.

glaze A glasslike coating applied to pottery. Also, any transparent coat, or layer of paint, in the fine arts.

gouache An opaque watercolor or a painting done in this medium.

grisaille A painting executed entirely in gray tones; popular in the classicist period as an underpainting.

hue A particular gradation of color; a shade or tint.

impasto A thick application of paint in a work of art. Formerly only possible in oils; now, with extender or an underpainting white, any medium can be used in impasto.

Marlene A liquid used to remove undesired color from photographs. It is colorless, rapid evaporating, and non-flammable. Unlike turpentine, it will not spread, shine when dry, or leave a ring.

medium The substance with which pigments are mixed, such as water, oil, casein, or wax. The ingredients added to various colors in order to make them more or less fluid, to cause them to dry faster or slower, and so on. Also, the material through which artists express their ideas and concepts, such as bronze, marble, enamel, or aquarelle.

monochrome Anything done in one color, or shades of one-and-the-same color; opposite of polychrome.

opacity The quality of not allowing light to pass through an object or material; the opposite of transparency.

palette The array of colors used in a painting. Also, the tray, dish, or other implement used to hold and mix the paints.

papier mâché A substance made of pulped paper or paper pulp mixed with glue and other materials or of layers of paper glued and pressed together, molded when moist to form various articles, and becoming hard and strong when dry.

pigment The coloring matter, which, mostly in powder form, is used in paints.

polymer A relatively new medium that is prepared from mostly diverse combinations of acrylic and vinyl. These colors are applied with water, but dry almost instantly and dry waterproof.

P.M. Solution A pre-treatment for papers and a corrective solution for removing colors.

reliquary A receptacle, such as a coffer or shrine, for keeping or displaying sacred relics.

repoussé Shaped in patterns that are raised in relief by hammering on the reverse side.

saturation The degree of intensity of a color.

scraffito A technique of ornamentation in which a surface layer is incised to reveal a ground of contrasting color.

tooth A rough surface created on a paper that grabs paint.

tortillions are an ideal blending tool for pastels and charcoal. Constructed of soft paper felts, rolled and pointed at one end.

value The relationship of any color to white (the lightest) and to black (the darkest) color.

varnish Final finishing product used to protect art. Exists in different formats: matte, shiny or satin to protect paintings.

watermedia The broad term for water-based painting media.

wet-into-wet Wet paint applied into a wet surface, another color, or ground; when paint and surface are both very wet, paint spreads and bleeding occurs.

wet-over-dry Wet paint applied over dry color, which will stay where you put it. Start with lightest colors, as the first color will show through the second color.

PRODUCT MANUFACTURERS BY PROJECT

Each project in this book is listed here by page number to help you locate manufacturers for the supplies used. To locate more information about a specific manufacturer see Product Resources, page 141.

Always in my toolbox:
Matte Medium (Golden)
Scissors (Cutter Bees)
hand cream (Gloves In A Bottle)
baby wipes to clean stamps
non stick craft sheet (Ranger)

Opening Pages

Page 5 *Mum & Dad*
Black and white photograph, blended fibers (Liquitex), gold mica flake (Golden), canvas (Reeves)

Contents

Pages 6-7 *Efflorescence*
Black and white photograph, transparent oil paints (Marshalls), printed on semi gloss photo paper, gesso (Golden), notch tool (Marshalltown)

Introduction

Page 9, *Connemara*
Black and White photograph, transparent oil paints (Marshalls)

Chapter 1
Page 11 *Portal*
Black and White photograph, transparent oil paints (Marshalls), acrylic paints acrylic paints (Golden and Lumiere), embossing powder (Stampin' Stuff), fabric, inks (Adirondack)

Page 12 *All That Jazz*
black and white photograph

Page 13 *Carpe Diem*
Color photograph, markers, Poster Paint pen (Sharpie), tinted walnut ink (EZ Walnut Ink & tintZ), markers (Tombow, Prismacolor)

Page 13 *Dancing By The Gate*
color photograph, bleach (Soft Scrub)

Page 14 *Bless You*
Digital image

Page 14 *Ritz Carpet*
Digital image

Page 15 *Olios* and *Olios* digital filter samples

Sepia photograph
Sepia photograph altered in Photoshop with filters

Page 16 *Dollhouse Ghosts, Ghost Shadows, Ghost Doorway, Ghost Windows, Ghost Flowers*
Polaroid manipulations altered with mechanical pencil tip, knitting needle, paper clip

Page 17 *Winter Wonderland*
Black and white photograph shot with Holga camera (www.lomography.com)

Page 17 *The Bakery*
Holga camera, Holga fisheye lens, (www.lomography.com), markers (Prismacolor)

Page 17 *Nut House*
Holga camera, Holga fisheye lens, (www.lomography.com), markers (Prismacolor)

Page 17 *Dublin Energy*
Holga camera (www.lomography.com)

Page 18 *Face It*
Color photograph, markers (Tombow), sandpaper

Page 19 *Afloat*
Black and white photograph printed on handmade paper (Carter Sexton)

Page 20 *Jesse*
Digital Photograph altered in Photoshop with filters

Page 21 *Quiet Mind*
Black and white photograph, transparent oil paints (Marshalls), oil color pencils (Marshall's and Beryl Prismacolor)

Page 22 *Undercover*
Black and white photograph, transparent oil paints (Marshalls), acrylic paints (Golden), pencils (Marshall's and Beryl Prismacolor), rubber stamps (Christine Adolph Stampington & Co., Savvy Stamps)

Page 23 *Sombrero*
Black and white photograph, transparent oil paints (Marshalls)

Page 23 *Closed Quarters*
Black and white photograph, transparent oil paints (Marshalls)

Page 23 *Food For Thought*
Black and white photograph, transparent oil paints (Marshalls)

Chapter 2

Page 25 *Alone in a Colorful World*
Black and White photograph, transparent oil paints (Marshalls), oil color pencils (Marshall's and Beryl Prismacolor)

Page 27 *Guardian of the Waters*
Black and White photograph, transparent oil paints (Marshalls)

Page 29 *Paint Swatches* (Golden, Nova Colors)

Page 30 *The Road Home #1* and *The Road Home #2*
Black and White photograph, transparent and extra strong oil paints (Marshalls), oil color pencils (Marshall's and Beryl Prismacolor)

Page 31 *Days End*
Black and White photograph, transparent oil paints (Marshalls), oil color pencils (Marshall's and Beryl Prismacolor)

Page 31 *Pit Stop*
Black and White photograph, transparent oil paints (Marshalls)

Page 32 *Aloha Jesse*
Sepia photograph, acrylic paints (Liquitex)

Page 32 *Catalina Seas*
Black and White photograph, strong transparent oil paints (Marshalls)

Page 33 *Becca's Bear*
Black and White photograph, transparent oil paints (Marshalls)

Page 33 *Thirteen*
Black and White photograph, transparent oil paints (Marshalls)

Page 34 *Whipped*
Black and white photograph printed on semi gloss photo paper, acrylic paints (Golden)

Page 34 *Birthday Girl Overlooking Central Park*
Black and white photograph printed on matte photo paper, acrylic paints (Golden)

Page 35 *Observer*
Black and white photograph, transparent oil paints (Marshalls), printed on glossy photo paper, pigment paints (Bocour pure pigments), crackle paste (Golden), Rakusui-shi paper, ephemera

Page 36 *Heaven Bound #1*
Black and White photograph, strong transparent oil paints (Marshalls), molding paste (Golden), acrylic paints (Golden and Lumiere), rubber stamps (JudiKins)

Page 37 *Heaven Bound #2*
Black and White photograph, strong transparent oil paints (Marshalls), rubber stamps (Green Pepper Press – Curvature, Romeo), Perfect Medium stamp pad (Ranger Inks), Perfect Pearls (Ranger Inks)

Page 38 *Crackle Cottage*
Black and White photograph, transparent oil paints (Marshalls), rubber stamp (JudiKins), dye ink pad (Ranger Adirondack)

Page 38 *Letters Home Cottage*
Black and White photograph, transparent oil paints (Marshalls), rubber stamp (A Lost Art), dye ink pad (Ranger Adirondack)

Page 39 *Grid Cottage*
Color photograph, rubber stamp (Magenta), dye ink pad (Ranger Adirondack)

Page 39 *Fleur Cottage*
Color photograph, rubber stamp (Anna Griffin – All Night Media)

Page 40 *Wand Feather #1*
Black and white photograph printed on photographic paper, watercolor crayons (Lyra)

Page 40 *Wand Feather #2*
Black and white photograph printed on watercolor paper, watercolor crayons (Lyra)

Page 41 *Look Up*
Black and White photograph, transparent oil paints (Marshalls) printed on matte photo paper, placed on watercolor paper, watercolor paints (Winsor & Newton)

Page 41 Watercolor Crayons sample
Lyra Aquacolor wax crayon sticks

Page 42 *Lucky Feather*
Black and white photograph, oil pastels (Sennelier)

Page 43 *Faux Zebra*
Black and white photograph printed on photo matte photo paper, oil sticks (Shiva)

Page 43 Oil Stick samples
oil pastel sticks (Sennelier)

Page 44 *A River Runs Through It*
Black & White Photograph, transparent oil paints (Marshalls), oil color pencils (Marshall's and Beryl Prismacolor)

Page 45 *Where's My Shovel?*
Black and White photograph, transparent oil paints (Marshalls), oil color pencils (Marshall's and Beryl Prismacolor)

Page 46 *A Pailful*
Black and white photograph, markers (Prismacolor, Pantone Letraset), pigment pens (Ranger Adirondack)

Page 47 *A Reflection On You #2*
Black and white photograph printed on glossy photo paper, markers (Tombow)

Page 48 *Winter Dance*
Vintage photograph, markers (Adirondack pigment pens), walnut ink (Paper Ink Arts), walnut color wash (7 gypsies), French fabric, gold stamped paper, sewing machine (Sew Crafty)

Page 49 Walnut Ink Samples
walnut ink crystals (Paper Ink Arts)

Page 49 *Wired*
Black and white photograph, transparent oil paints (Marshalls), walnut ink crystals (Paper Ink Arts)

Page 50 *Whippersnappers*
Black and white photograph, transparent oil paints (Marshalls), gesso (Golden), fluid acrylics (Golden) acrylic paint dabbers (Adirondack)

Page 51 *Bridges*
Black and white photograph, transparent oil paints (Marshalls), gold gesso (Daniel Smith), joss paper (Stampington & Company)

Page 52 *Light Show*
Black and white photograph, gesso (Golden), white pen (Y&C Gel Xtreme), rubber stamps (Doodles and Carvings – Bonkers Handmade Originals)

Page 53 *Poor Dolly*
Vintage black and white photograph printed on matte photo paper, black gesso (Golden), India Ink (Sennelier) fabric scrap, white pen (Y&C Gel Xtreme), chalk paint pen (Chalk Ink Markers), black gel pen (Sekura Gelly Roll)

Page 54 *Dwelling*
Black and white photograph printed on glossy photo paper, inks (Ranger Adirondack Alcohol Inks)

Page 54 *Scramble*
Black and white photograph printed on glossy photo paper, paper towel, inks (Ranger Adirondack Alcohol Inks), Cut-n-Dry Nibs (Ranger)

Page 54 *Shanty*
Black and white photograph printed on glossy photo paper, inks (Adirondack Alcohol Inks), Cut-n-Dry Foam (Ranger)

Page 54 *Abode*
Black and white photograph printed on glossy photo paper, ink (Adirondack Color Wash), dental tool

Page 55 *Five Lives*
Black and white photograph printed on glossy photo paper, ink pad (Adirondack), Crackle Accents (Ranger)

Page 55 *Cache*
Black and white photograph printed on glossy photo paper, ink (Adirondack Alcohol Inks)

Page 73 *Wishes and Dreams #2*
Clear vellum paper, gesso (Golden), stamped with corrugated cardboard

Page 74 *Cuppa Tea*
Canvas (Masterpiece Arts), vintage photograph, transparency (Angela Cartwright Collection "Cottage Garden" - Stampington & Company), acrylic paint (Adirondack), handmade paste paper (Albie Smith)

Page 75 *Reliquary*
Canvas frame (Masterpiece Arts), transparency (Angela Cartwright Collection "Stone Portals" – Stampington & Co.), paint, (Lumiere), molding paste (Golden), button, silk ribbon (Midori), ephemera

Page 75 *Desert Opus*
Transparency (Angela Cartwright Collection "Casa Vista"– Stampington & Company) gesso (Golden), paper made with notch tool (Marshalltown), sheet music

Page 75 *Fruit For Thought*
Computer generated transparency from hand-painted photograph, acrylic paint (Adirondack)

Page 76 Interior Paint Samples
Interior Paint (Benjamin Moore color samples), woolly paint roller (Modern Masters), sea sponge, wood grain texture tool, Foam Stamps (Chunky Décor Stamps – Duncan Enterprises), Rubber Stamps (Green Pepper Press)

Page 77 *If These Walls Could Talk*
Black and white photograph, strong transparent oil paints (Marshalls), texture background with crackle and molding paste (Golden), acrylic paints (Golden), artwork printed on glossy paper, pre mixed stucco patch (Custom Building Products), interior house paint (Benjamin Moore), foam rubber stamps (Making Memories)

Chapter 4

Page 79 *Oriel*
Canvas (Masterpiece Arts), transparency (Angela Cartwright Collection "Cottage Garden" – Stampington & Co), acrylic paint (Golden), mesh, paper, cheesecloth, ephemera

Page 80 *Bird in the Hand*
Hand carved stamp, carving block (Speedball), acrylic paint (Golden)

Page 80 *Red Bird for Sarah*
Hand carved stamped art (Speedball), acrylic paint (Golden)

Page 81 *Kettles On*
Black and white photograph painted with transparent oil paints (Marshalls), rubber stamps (Celtic designs), embossing pad (Ranger Big & Bossy), embossing powder, (Stampendous Pearl Lustre Peridot)

Page 81 *Silver Chairs*
Rubber Stamp (Green Pepper Press – Please Be Seated), embossing powder (Ranger Big & Bossy), embossing powder, (Stampendous Pearl Lustre Sterling Silver), embossing pen (Ranger)

Page 82 *Winter Wonderland*
Black and white photograph painted with dye based ink pads (Distress Ink pad), sandpaper

Page 82 *Ornamental*
Black and white photograph painted with chalk ink pads (Colorbox Fluid Chalk Ink pad)

Page 82 *Toto Too*
Clear Gesso (Liquitex), black and white photograph painted with dye based ink (Distress Ink pads)

Page 83 Milk Stamping samples 1 & 2
Foam stamps (Chunky Décor Stamps Duncan Enterprises), rubber stamps (B Line Designs), condensed milk

Page 83 *The Dark Side*
Black and white photographs on matte photo paper, vintage photographs, bleach (Soft Scrub), String gel (Liquitex), acrylic paints (Golden), white pen , black glaze pen, chalk ink (Chalkboards, Ink) , white stamp pad (Brilliance – Moonlight White), rubber stamps (Magenta, The Moon Rose), foam stamps (Making Memories), wallpaper scrap

Page 84 Imprint sample
Gesso (Golden), various implements

Page 85 *On Golden Shore*
Black and white photograph painted with transparent oil paints (Marshalls), scanned onto canvas (Pictorico), acrylic paints (Golden), plastic wrap

Page 85 Plastic wrap and bubble wrap samples, acrylic paints (Golden)

Page 86 Alphabet Stencils
(C-Thru)

Page 86 Grapes stencil
Stencil (Dard Hunter), Crackle paste (Golden), acrylic paint (Golden), palette knife, sandpaper

Page 87 Stencil Under Images
Color photograph, stencils (C-Thru, vintage circle guide)

Page 87 *Light Bearer*
Transparency (Angela Cartwright Collection "Casa Vista" – Stampington & Co)

Page 88 *Footprints*
Black and White photograph, transparent oil paints (Marshalls), walnut ink, fabric, handmade papers, sewing pattern, postage stamp, brads (Making Memories)

Page 89 *Farm Barn*
Black and white photograph, markers (Prismacolor), vintage fabric, fibers (The Pink Porch)

Page 89 *Laced Up*
Sepia photograph, walnut ink (Paper Ink Arts), vintage lace

Page 89 *Mission Perspective*
Black and white photograph, transparent oil paints (Marshalls), yarn (The Pink Porch)

Page 89 *Urning For You*
Black and white photograph, markers (Prismacolor), vintage fabric, fibers (The Pink Porch)

Page 90 *Super Kids*
Black and white image printed on transparency (3M transparency film), vintage photographs, markers (Tombow), artist paper (Angela Cartwright Collection– "Cottage Garden" Stampington & Co.), clear labels (Avery)

Page 90 Handmade Papers
Amate paper (Amate International)

Page 91 *Passage*
Sepia photograph, transparent oils (Marshalls), acrylic paint (Golden), inks (Adirondack), Rakusui-shi paper, ephemera

Page 91 Joss Papers (Stampington & Co.)

Page 92 *Structure*
Black and white photograph painted with strong transparent oil paints (Marshalls), embossed paper (Graphic Products Corporation), embossing powder (Adirondak), acrylic paint (Golden), postage stamp, encaustic wax (R&F Encaustic Medium)

Page 92 Embossed Paper and Paintable Wallpaper Samples
Papers (US, Graphic Products Corporation, Textured Wallpapers (Anaglypta, Lincrusta - FY Home)

Page 93 Marble Paper Samples
(Jacquard Products, Graphic Products Corporation, Amante International)

Page 94 *Lullaby*
Vellum (Angela Cartwright Collection "Cottage Garden" Stampington & Co.), acrylic paint (Golden), inks (Adirondack), walnut ink (Paper Ink Arts), gesso (Golden), cotton cloth, sewing tape, ephemera

Page 95 *Nesting*
Black and white photograph painted with transparent oil paints (Marshalls), molding paste (Golden), rubber stamp (Christine Adolph "Collage Cube" Stampington & Co), corrugated paper

Page 95 Tape Samples
Masking and colored tape (Scotch, Shurtape), reinforcement labels (Avery), label tape (DYMO)

Page 96 *More*
Black and white photograph painted with transparent oil paints (Marshalls), acrylic paints (Golden), molding paste (Golden), pigment ink stamp pads (Dr. Ph. Martin's InkPak), eggshells, sandpaper, mesh

Page 97 *Blest*
Black and white photograph painted with transparent oil paints (Marshalls), mica (US Art Quest), walnut ink (Paper Ink Arts), Gold Mica Flake (Golden), ephemera

Page 97 Glitz Samples
Sequins (Chenille Kraft), Glitter (Cartwrights Glitter), Glass Shards (Vintage Glass Glitter), Micro Beads (Halcraft Tiny Glass Marbles)

Page 98 *1919*
Black and white photograph painted with transparent oil paints (Marshalls), acrylic paint (Golden), ephemera

Page 99 Tissue and Napkin Samples
guest towels (Caspari), various gift tissues, floor plan tissue (7Gypsies), newspaper

Page 100 *The Storyteller*
Black and white hand-painted photograph painted with transparent oil paints (Marshalls), rice paper, Copper Effects paint (Modern Masters), patina solution (Modern Masters),

faux simulated liquid leading (Plaid)

Page 100 *The Urn*
Black and white photograph altered in Photoshop, embossed paper (Graphic Products Corporation), rust solution (Modern Masters)

Page 101 *Bare Bones*
Black and white photograph made into an etching, scanned onto canvas (Pictorico), china crackle (Modern Masters), china crackle enhancer dark (Modern Masters)

Page 101 *Tree Music*
Transparency (Angela Cartwright Collection "Casa Vista" – Stampington & Co.), china crackle, (Modern Masters), china crackle enhancer light (Modern Masters)

Page 102 *Gateway*
Black and white hand-painted photograph painted with transparent oil paints (Marshalls), paint (Golden, Lumiere) embossing powder (Stampin' Stuff), molding paste (Golden), encaustic wax (R&F Encaustic Medium)

Page 103 *Message*
Black and white hand-painted photograph painted with transparent oil paints, acrylic paint (Golden), molding paste (Golden)

Page 104 *She Wandered*
Black and white photograph printed on organza (ExtravOrganza Jacquard), Artist Paper (Angela Cartwright Collection "Cottage Garden" – (Stampington & Co.), oil pastels (Sennelier)

Page 105 *Monica*
Black and white photograph hand-painted with oils photocopied on silk (Jacquard), vintage brocade fabric

Page 105 *Placida*
Black and white hand-painted photograph painted with transparent oil paints (Marshalls), photocopied on cotton (Jacquard), inks (Adirondack), linen

Page 106 *The Promise*
Black and white hand-painted photograph painted with transparent oil paints (Marshalls), photocopied on canvas (Jacquard), acrylic paint (Adirondack Dabbers), rubber stamp (Penny Black), gesso (Golden), oil pastels (Sennelier)

Page 107 *Wing And A Prayer*
Sepia photograph transferred onto linen fabric (Canon t-shirt transfers), ink

stain (Modern Masters – China Crackle enhancer dark)

Page 107 *Celeste*
Black and white photograph transferred with Tranz It! (Judikins), Bristol paper

Page 108 *Dorothy*
Vintage photograph, papers, transparency (Angela Cartwright Collection "Cottage Garden" – Stampington & Co.), ledger paper, paper, text, embossing powder (Stampin' Stuff)

Page 109 *Forgive*
Acrylic paint (Adirondack Dabbers), lipstick (MAC), tissue, Rub-Ons (K&Company), stamp pad ink (Distress Pads)

Page 109 *Be Strong*
Acrylic paint (Nova Color), computer generated transparency from hand-painted photograph, stamp pad ink (Distress Pads), Rub-Ons (7 Gypsies)

Page 109 Transparency sample
Computer generated transparency (3M) Acrylic paint (Nova Color),

Page 110 *Kimi Sketch* and *Lizi Sketch*
Graphite pencil (Cretacolor Monolith Woodless Pencil), sketches enhanced in Photoshop

Page 110 Pencil Sketches
Graphite pencil (Cretacolor Monolith Woodless Pencil)

Page 110 *Blossoming*
Black and white hand-painted photographs painted with transparent oil paints (Marshalls), vellum (Angela Cartwright Collection "Cottage Garden" – Stampington & Co.), charcoal sketch, sheet music

Page 111 *Happiness*
Black and white photograph printed on watercolor paper, colored soluble graphite pencils (Derwent Graphitint), ink (Adirondack), photo corners (CR Gibson)

All Photographs by Angela Cartwright

Black and White film developing and printing Franks Custom Lab
www.astudiogallery.com

PRODUCT RESOURCES

ADHESIVES

Matte Medium www.goldenpaints.com
Perfect Paper Adhesive Matte
 www.usartquest.com
UHU stic www.saunders-usa.com/uhu
Art Glitter Designer Adhesive
 www.artglitter.com
Xyron Machine www.xyron.com

APPARATUS

Canon EOS, Canon Rebel www.canon.com
Polaroid www.polaroid.com
Holga www.lomography.com
notch tool www.marshalltown.com
Sew Crafty mini sewing machine
 www.stampington.com/html/sew_
 crafty_sewing_machine.html

COMPUTER MATERIALS - FABRIC & PAPERS

Canvas www.pictorico.com
Clear labels www.avery.com
Cotton www.jacquardproducts.com
Organza ExtravOrganza
 www.jacquardproducts.com
Silk www.jacquardproducts.com
Transparency Film 3M www.staples.com
Watercolor Paper www.pictorico.com

CUSTOMIZED POSTAGE STAMPS

Angela Cartwright postage stamps
 www.cafepress.com/acartwright/814223
www.photostamps.com
www.pictureitpostage.com/Postage

EMBELLISHMENTS

www.ccartwright.com
www.chenillekraft.com
www.skybluepink.com/punchinella.html
www.halcraft.com
ArtChix www.artchixstudio.com

EMBOSSING POWDERS

Distress www.rangerink.com
Perfect Pearls www.rangerink.com
Stampendous www.stampendous.com
Stampin' Stuff www.stampinstuff.com
Utee www.schmoozewithsuze.com

EPHEMERA

Flea markers
www.papiervalise.com
www.hannahgrey.com

FIBER AND YARN

Fiber On A Whim
 www.fiberonawhim.com
Making Memories
 www.makingmemories.com
Midori www.midoriribbon.com
The Pink Porch www.thepinkporch.com

FINISHES

Acrylic Glazing Liquid Satin
 www.goldenpaints.com
Gloss Varnish, Gloss Medium, Varnish
 www.Liquitex.com
Krylon Clear Matte Spray
 www.krylon.com
Marlene www.dickblick.com
Marshalls Pre Color Spray
 www.swains.com
MasterClear protective clear Topcoat
 www.modernmastersinc.com

FONTS

www.misprintedtype.com
www.fonthead.com/index.php
www.fontgod.com

GESSO

white and black gesso
 www.goldenpaints.com
gold gesso www.danielsmith.com
colored gesso www.liquitex.com

INKS

Adirondack Inks Ranger www.rangerink.com
Adirondack Color Wash
 www.rangerink.com
Color wash www.sevengypsies.com
EZ TintZ www.fiberscraps.com
Walnut Ink
 www.paperinkarts.com/shop.html
Fiber Scraps Walnut Ink
 www.fiberscraps.com
India Ink Sennelier www.dickblick.com
Paper Ink Arts Walnut Ink crystals
 www.paperinkarts.com

MARKERS

Chalk Ink Markers www.chalkink.com
Pantone Letraset www.letraset.com
Prismacolor www.prismacolor.com
Sharpie Poster Paint www.sharpie.com
Tombow www.tombowusa.com

MICA

Sheets www.usartquest.com
Gold Mica Flake www.goldenpaints.com

OIL STICKS, PASTELS, AND CRAYONS

Lyra Aquacolor Water Soluble Crayons
 www.jerryartarama.com
Oil paintsticks www.dickblick.com
Oil pastels www.sennelier.fr

PAINT

Adirondack Acrylic and Dabbers
 www.rangerink.com
Benjamin Moore color samples
 www.coxpaint,com
Bouchor pure pigments flea market find
Golden www.goldenpaints.com
Liquitex www.liquitex.com
Lumiere www.jacquardproducts.com
Marbling www.jacquardproducts.com
Marshalls Photo oil paint
 www.dickblick.com
 www.cartersexton.com
Modern Masters Effects Paint-Rust and
Patina solutions
 www.modernmastersinc.com
Nova Color www.novacolorpaint.com
Simulated Liquid Leading
 www.plaidonline.com
Watercolor paints
 www.winsornewton.com
Watercolor palette www.usartquest.com

PAPER

Angela Cartwright Artist Papers, transparencies and vellums
 www.acartwrightstudio.com/acartist
 papers.htm
Embossed Paper www.handmade-paper.us
Embossed Wallcovering www.fyhome.com
Fabriano www.dickblick.com
Joss Paper www.stampington.com

PAPER (CONTINUED)

Marble and Amate papers
www.amateinternational.com
Marbling kits for paper and fabric
www.jacquardproducts.com
www.gpcpapers.com
www.hannahgrey.com
www.japanesepaperplace.com
www.cartersexton.com
www.swainsart.com

PASTES & GELS

Black lava www.liquitex.com
Blended fibers www.liquitex.com
China crackle www.modernmasters.com
Crackle accent www.rangerink.com
Crackle paste www.goldenpaints.com
Course pumice gel
www.goldenpaints.com
Garnet gel www.goldenpaints.com
Glass bead gel www.liquitex.com
Gloss gel medium www.goldenpaints.com
Heavy pumice paste
www.goldenpaints.com
Molding paste www.goldenpaints.com
Resin sand texture www.liquitex.com
String gel www.liquitex.com
Stucco paste www.liquitex.com
Stucco patch www.acehardware.com
Tranz It! transfer gel
www.schmoozewithsuze.com
White opaque flakes www.liquitex.com

PENCILS AND PENS

Beryl Prismacolor
www.dickblick.com/vendors/prismacolor
Cretacolor Monolith Woodless Pencil
www.dickblick.com
Derwent Graphitint www.dickblick.com
Gelly Roll glaze pens www.gellyroll.com
Marshalls Oil Pencils www.dickblick.com
Milky Lunar gel roller www.pentel.com
Souffle pens www.gellyroll.com
Uniball Signo pen www.uniball-na.com
Y&C Gel Xtreme pen www.dickblick.com

RUB-ONS

7 Gypsies www.sevengypsies.com
K & Company www.kandcompany.com
www.scrappindaisy.com
Making Memories
www.makingmemories.com

STAMP PADS

Big & Bossy Embossing Stamp pad
www.rangerink.com
Brilliance www.tsukineko.com
Colorbox www.clearsnap.com
Distress Ink Pads www.rangerink.com
Dr. Ph. Martin's www.docmartins.com
StazOn www.tsukineko.com

STAMPS

Above The Mark www.abovethemark.com
A Lost Art vintage stamp
All Night Media
www.plaidonline.com/apANM.asp#wm
Bonkers Handmade Originals
www.bonkersfiber.com
Custom stamps www.motherrubber.com/
CustomStamps.html
Christine Adolph www.stampington.com
The English Stamp Company
www.englishstamp.com
Foam stamps www.duncancrafts.com
www.makingmemories.com
www.wilde-ideas.com
Green Pepper Press
www.greenpepperpress.com
Judikins www.judikins.com
Magenta www.magentastyle.com
The Moon Rose
www.themoonroseartstamps.com
Penny Black www.pennyblackinc.com
Post Modern Design www.wilde-ideas.com
Savvy Stamps www.savvystamps.com
Stampers Anonymous
www.stampersanonymous.com
Stampington & Co www.stampington.com

STENCILS

Alphabet and circle stencils
www.cthruruler.com
Dard Hunter Studios www.dardhunter.com
Stencils www.madstencilist.com

SUBSTRATES

Canvas Fredrix
www.fredrixartistcanvas.com
Masterpiece Arts www.masterpiecearts.com
Reeves www.reeves-art.com
Clayboard Ampersand Art Supply
www.ampersandart.com
Carving Block Speedball
www.speedballart.com

TOOLS

Alvin Cutting Mat www.dickblick.com
C-Thru rulers www.cthruruler.com
Cut-n-Dry foam www.rangerink.com
Cut-n-Dry pen nibs www.rangerink.com
Cutter bees scissors www.eksuccess.co
Dyno Label Maker www.dyno.com
Masking www.3M.com
Color tape www.shurtape.com
Nonstick craft sheet www.rangerink.com
Speedball carving tools
www.speedballart.com
Tortillions www.danielsmith.com
X-acto knife and blades
www.dickblick.com

WAX AND LEADING

Beeswax pellets
www.schmoozewith-suze.com
DS Beeswax Pastilles
www.danielsmith.com
Faux liquid leading
www.plaidonline.com
Gamblin Wax Pastilles
www.dickblick.com
R&F Encaustic Medium
www.dickblick.com

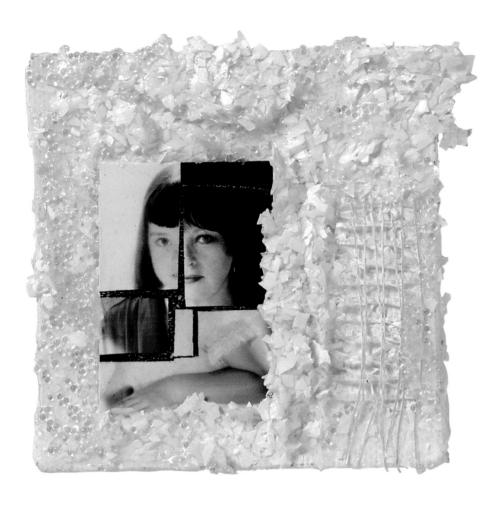

ABOUT THE AUTHOR

Angela Cartwright, known for her acting roles in *Make Room for Daddy*, *The Sound of Music*, and *Lost In Space*, has been a photographer and an artist for more than four decades. Her work is exhibited and collected internationally. Angela reinterprets her unique hand-painted photographic art with the use of acrylics, oil paints, inks, written words, and ephemera. She is the co-author, with Sarah Fishburn, of *In This House: A Collection of Altered Art Imagery and Collage Techniques* (Quarry Books, 2007). She writes articles regularly for art magazines, teaches new methods of combining imagery with art, and curates A Studio Gallery in Los Angeles, where she also makes her home. www.acartwrightstudio.com

TIMELINE

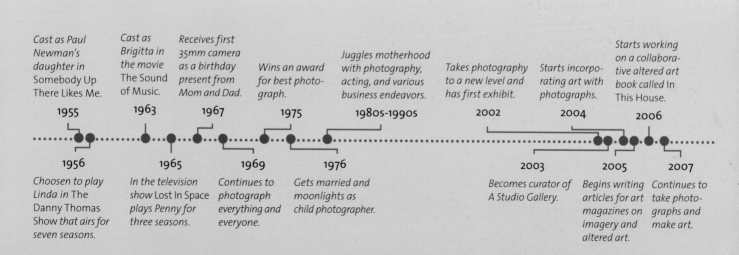

1955 Cast as Paul Newman's daughter in Somebody Up There Likes Me.

1956 Chosen to play Linda in The Danny Thomas Show *that airs for seven seasons.*

1963 Cast as Brigitta in the movie The Sound of Music.

1965 In the television show Lost In Space plays Penny for three seasons.

1967 Receives first 35mm camera as a birthday present from Mom and Dad.

1969 Continues to photograph everything and everyone.

1975 Wins an award for best photograph.

1976 Gets married and moonlights as child photographer.

1980s-1990s Juggles motherhood with photography, acting, and various business endeavors.

2002 Takes photography to a new level and has first exhibit.

2003 Becomes curator of A Studio Gallery.

2004 Starts incorporating art with photographs.

2005 Begins writing articles for art magazines on imagery and altered art.

2006 Starts working on a collaborative altered art book called In This House.

2007 Continues to take photographs and make art.

> The camera is a simple apparatus, even the most inept person can use it; the challenge lies in creating with it that combination of truth and beauty called art.
>
> —ISABEL ALLENDE

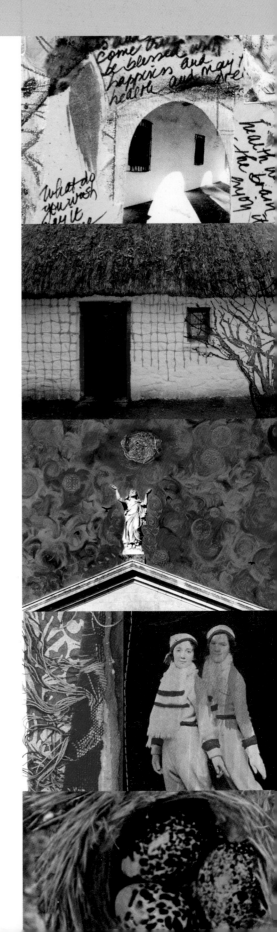

ACKNOWLEDGMENTS

To Winnie Prentiss and Ken Fund, who gave the green light to this second book while the first one was going to press, I thank you for the opportunity. To Mary Ann Hall for her input and guidance through the mixed emotions during the creation of this tome, to Alissa Cyphers for her eagle eye, and to the clan at Rockport/Quarry: David Martinell, Rochelle Bourgault, John Gettings, Cora Hawks, Mary Aarons, I am so grateful for your involvement.

To my partners in art who so generously contributed their talents into mixing their own emulsions so they could share them with the readers of this book. I thank you from the bottom of my heart:

My comrade and red bird, Sarah, who feeds and reads my muse;

CW, a constant channel of inspiration, not only in art but in everything in between;

And to Anahata, Ashley, Céline, Claudine, Deryn, Elaine, Erika, JoFish, Katina, Kelly, Lesley, m., Michelle, Misty, Scott, Shirley, Susie, Tiffini, and Traci. I am truly grateful.

To the wizards in the darkroom, Mardjie and Vince of Franks Custom Lab; Bristol MacDonald, for lending her talents, and Bonnie at Ranger Ink, thank you, thank you, thank you.

To my amazing circle of friends whose words of encouragement and trust never go unnoticed.

To Mum and Dad who have loved and believed in me since the day I was born, and to Veronica and Chris for always being there.

I must acknowledge the "heartbeat at my feet," my sheltie Peyton, who was my constant companion while I typed away. A more faithful friend cannot be found.

And last but certainly not least to Steve, Becca, and Jesse, who continually embrace me with love and support above and beyond. By accepting my passions unconditionally you enrich my life more than you know.